EGYPTIAN ART

The books in this series provide a convenient and access-ible introduction to subjects within the applied arts. Drawing examples from the world-famous collections at the Fitzwilliam Museum, they furnish the reader with a wide variety of information on many different types and forms and illustrate some of the most famous as well as the most unusual examples. A general introduc-tion is followed by entries on sixty-four individual objects, each of which is illustrated in colour. Complete with glossaries and guides to further reading, these books will prove invaluable to all collectors and enthusiasts.

EGYPTIAN ART

ELENI VASSILIKA

KEEPER OF ANTIQUITIES,

FITZWILLIAM MUSEUM WITH

CONTRIBUTIONS FROM JANINE BOURRIAU

PHOTOGRAPHY BY BRIDGET TAYLOR

AND ANDREW MORRIS

CAMBRIDGE
UNIVERSITY PRESS

Published by the Press Syndicate of the University of Cambridge
The Pitt Building, Trumpington Street, Cambridge CB2 1RP
40 West 20th Street, New York, NY 10011-4211, USA
10 Stamford Road, Oakleigh, Melbourne 3166, Australia

© Fitzwilliam Museum 1995

First published 1995

Printed in Great Britain at the University Press, Cambridge

A catalogue record for this book is available from the British Library

Library of Congress cataloguing in publication data
Vassilika, Eleni.
Egyptian art / Eleni Vassilika with contributions from Janine Bourriau;
photography by Bridget Taylor and Andrew Morris.
p. cm. – (Fitzwilliam Museum handbooks)
Includes bibliographical references.
ISBN 0 521 47519 8 (hardback). ISBN 0 521 47518 X (paperback)
1. Art, Egyptian
2. Art, Ancient – Egypt
I. Bourriau. II. Fitzwilliam Museum. III. Title. IV. Series.
N5350.V35 1995
709'.32'07442659–dc20
94–36382 CIP

ISBN 0 521 47519 8 hardback
ISBN 0 521 47518 X paperback

This book is dedicated to
Bob Bourne, Julie Dawson,
Louise Jenkins and Penny Wilson
who breathe life into the ancient art
in the Fitzwilliam Museum

CONTENTS

Introduction 1

Glossary of Egyptian deities 5

1 MOULDED ANIMAL VASE · 4000–3000 BC 10

2 OBJECTS FROM THE HIERAKONPOLIS TEMPLE 12
DEPOSIT · 4000–3000 BC

3 LION GAMING PIECES · between 2920 and 2770 BC 14

4 EARLY DYNASTIC STONE VESSELS · between 3000 16
and 2649 BC

5 FOREIGN CAPTIVE · 2630–2611 BC 18

6 INTKAES AND HER DAUGHTERS · 2480–2255 BC 20

7 HEMI-RE, PRIESTESS OF HATHOR · 2134–1982 BC 22

8 KING NEBHEPETRE MENTUHOTEP · 2040–2021 BC 24

9 STATUETTE FRAGMENT OF A MAN · 1991–1962 BC 26

10 STATUETTE FRAGMENT OF A WOMAN · 1991–1962 BC 28

11 KING SENWOSRET III · 1878–1843 BC 30

12 KING AMENEMHAT III · 1842–1797 BC 32

13 THE SOLDIER KHNEMU · 1842–1730 BC 34

14 THE SOLDIER USERHAT · 1878–1843 BC 36

15 MOURNING WOMAN · 1862–1648 BC 38

16 HEDGEHOG AND JERBOA · 1963–1648 BC 40

17 AMENEMHAT NEBUY AND HIS FAMILY · 1842–1786 BC 42

18 BOUND NAKED WOMAN · 1862–1648 BC 44

19 RELIEF OF THE QUEEN MOTHER · 1479–1457 BC 46

20 KEREM AND ABYKHY · 1465–1455 BC 48

21 DYNASTY XVIII TOMB GROUP OF AN EGYPTIAN 50
LADY · 1479–1425 BC

22 OBJECTS FROM THE BOUDOIR · 1391–1295 BC 52

23 BRONZE HEAD OF A KING · 1391–1353 BC 54

24 THE GOD BES · 1391–1353 BC 56

25 HAND-HELD SHELL · 1391–1295 BC 58

26 RELIEF OF THE HERETIC KING AKHENATEN · 60
1353–1337 BC

27 A ROYAL EMBRACE · 1353–1337 BC 62

28 HEAD OF AN AMARNA PRINCESS · 1347–1345 BC 64

29 AMARNA RELIEF OF SOLDIERS · 1353–1337 BC 66

30 HEAD OF HATHOR FROM A JAR · 1353–1337 BC 68

31 SHAWABTI OF SENNEDJEM · 1294–1279 BC 70

32 HEAD OF HATHOR · 1279–1213 BC 72

33 BLOCK STATUE · 1279–1213 BC 74

34 MODEL INK PALETTE · 1279–1213 BC 76

35 MONKEY BUSINESS · 1350–1250 BC 78

36 DRAWING OF A MAN ON A POT-SHERD · 1295–1069 BC 80

37 UNSHAVEN STONE MASON · 1200–1153 BC 82

38 JEWELLERY · 2000–fourth century BC 84

39 COFFIN LID OF RAMESSES III · 1184–1153 BC 86

40 PAPYRUS OF INPEHUFNAKHT · 1070–945 BC 88

41 THE SYCAMORE GODDESS · 990–969 BC 90

42 COFFIN OF NEKHTEFMUT · 924–889 BC 92

43 THE CHANTRESS OF AMUN, TENTESAMUN · 945–715 BC 94

44 TORSO OF KING SHOSHENQ · 767–730 BC 96

45 A STRIDING SPHINX · 1069–715 BC 98

46 THE GOD MIN-AMUN · 1069–715 BC 100

47 THE GOD PTAH · 1069–715 BC 102

48 RELIEF OF THE GOD AMUN · 780–656 BC 104

49 A DIVINE CONSORT · 780–656 BC 106

50 SHAWABTI OF HORKHEB · 715–610 BC 108

51 THE GODDESS NEITH · 715–525 BC 110

52 VOTIVE STATUETTE WITH THE IMAGE OF 112
PTAH · 715–610 BC

53 CARIAN GRAVE STELE · 550–500 BC 114

54 RELIEF OF KING ACHORIS · 392/1–379/8 BC 116

55 DOORJAMB OF THA-ISET-IMU · 378–360 BC 118

56 QUEEN ARSINOE II · middle of the second century BC 120

57 NAKED WOMAN · 300–275 BC 122

58 ISIS AND HARPOKRATES · 300–275 BC 124

59 THE VANQUISHED ENEMY · fourth–third century BC 126

60 SCULPTOR'S MODEL OF A GODDESS · 246–222 BC 128

61 THE GODDESS TAWERET · second–first century BC 130

62 A MATURE MALE HEAD · first century AD 132

63 A MUMMY · second century AD 134

64 COPTIC CASKET · fourth century AD 136

Selected bibliography and abbreviations 138

INTRODUCTION

This book is an introduction to four thousand years of Egyptian art illustrated by a selection of highlights from the collections of the Fitzwilliam Museum at the University of Cambridge. Like most Egyptian art collections, much of the ancient material in the Fitzwilliam was assembled by purchase, bequest or gift, the main criteria being aesthetic and art historical merit. This distinguishes the Fitzwilliam from those museums where archaeology and social history have been the prime considerations.

Apart from the minority of objects which have been received from excavations in Egypt that were supported by the museum, the origin of individual pieces – for example, their temple, tomb or town – is often not known for certain. The nature of Egyptian art, however, and the frequent inscriptions mean that we can usually show whether the individual works of art assembled here once belonged to royal or private persons, and how they might have served their funerary, religious and secular needs. Despite the impression given by some books, there is more to Egypt than just the funerary arts of the pharaonic period.

While the photographs illustrate the artistry and skills of the Egyptian craftsperson, the accompanying descriptions aim to acquaint the reader with the materials and methods of manufacture used and to introduce various aspects of ancient Egyptian iconography, religious beliefs and social and cultural history. Some everyday items, genre and trial pieces, charming in their own right, provide an intimate glimpse of the more human aspect.

Ancient Egyptian art has been traditionally viewed as the most visually evocative of ancient societies and, at the same time, the most conservative. Indeed, there are certain conventions, some of which seem almost naive to us, such as the face, limbs and lower trunk being generally shown in profile in two-dimensional art, whereas the shoulders were shown *en face*. Hierarchies determined scale so that mortals are shorter than deities and rulers, females shorter than males and subsidiary figures such as servants and children are even smaller. The figure, both in two- and three-dimensions was laid out on a grid so that knees, buttocks, armpits and shoulders could be fixed to horizontal guidelines. For example, at certain periods, for a standing figure this was composed of eighteen squares from the soles of the feet to the hairline. The grid was a useful guide to the original artist, but license was employed by the draughtsman and the points at which the body parts were fixed was not only variable,

but could be deliberately altered as one formal style replaced another. Indeed, early in the Late Period (eighth century BC) a twenty-one square grid was introduced, lined up with the upper eyelid of the figure not the hairline. This resulted in an elongation of the trunk of the body, and a shortening of the legs relative to the New Kingdom figures, proportions that related to Old and Middle Kingdoms forms.

In addition to the changes in figural proportions, many other stylistic changes occurred, both in the structure of the idealizing youthful faces and in the style and shapes of the wig, the drapery and even gestures. Many of these art historical bench-marks are noted in the following entries. Our understanding of the changes and variations in Egyptian art depends on detailed studies of individual classes of object. In some areas considerable work has been done, such as in the study of certain classes of sculpture and coffins; in other cases, particularly in the study of materials and techniques, much remains to be undertaken.

A politically unstable period could result in a breakdown in the artistic workshops and formal art (no. 7), whereas a strong rule could result in the introduction of naturalism to the royal image (no. 11). The king's desire to portray himself in unusual ways reached an extreme during the reign of the heretic Akhenaten (nos. 26, 27). The art historian's task is facilitated by the correlation between images of deities and individuals and the image of the reigning king especially when taken to mannerist extremes (nos. 13, 28, 32, 33).

It was not until the introduction of a stark realism in sculpture in the seventh century BC that private sculptures increasingly ceased to relate to royal images and began to develop portrait-like distinction (no. 62). Remarkably, this did not extend to images of women.

The mode of representation also differed according to the function of the object, the social stratum of the owner and the material. In some cases the precise meaning or identity of an object can still elude us, such as the bound female terracotta figure with beaked face (no. 18).

It is not always possible to distinguish between objects of daily use that were subsequently placed in the tomb, and objects made explicitly for the tomb. Clearly, among the latter were coffins, shawabtis and the Book of the Dead papyri, but sculptures and stelae were both included in the graves or deposited in temples. Sometimes large sculpted stones from funerary contexts were found reused in other buildings (nos. 53, 55). Thus, exact archaeological context is not always relevant to our understanding of an object's original function.

The funerary or cult significance of many of the objects in this book is underlined by their depiction of, or relationship to, particular deities. Most of the main Egyptian gods and goddesses can be found here. The Egyptians attributed specific powers and natural human qualities to their gods. In representations, deities were distinguished by their animal manifestations and by their particular attributes. For example, most deities have a crown specific to them, and some can wear more than one. Deities could also wear the uraeus cobra on the forehead, but unlike the king, this was not invariable. The deities depicted or referred to in this book are described briefly in the glossary.

Only a minute selection of objects is presented here, chosen by me and my predecessor Ms Janine Bourriau. Those entries written by Janine Bourriau are shown by her initials at the end of the section. The authors are grateful to Dr Mark Collier for his expertise in the Egyptian texts, and to Professor Geoffrey Martin and Dr Penny Wilson for their insights. Profound thanks are also due to Bridget Taylor and Andrew Morris for the splendid photographs, some of which required great technical expertise. This book would also not have been possible without the generosity of those connoisseurs and benefactors whose names appear at the top of each section.

GLOSSARY OF
EGYPTIAN DEITIES

Amun was the chief god of Thebes (modern Luxor). He was shown as a man, ram or ram-headed man. According to the legend of the birth of the king, it was Amun who impregnated the queen consort with the future king. Thus, Amun shared the creation qualities and the ram image with its fertility associations of the god Min (Min-Amun). Amun assimilated the solar power of Re (Amun-Re) and perhaps the role of taking the sun on its nightly journey through the underworld, which explains his rule over the dead. His consort was Mut, and their offspring was Khons.

Anubis was a jackal god who, as patron of embalmers, protected the dead.

Apis was a living bull and was worshipped as a god, unlike other gods who had animal manifestations.

Aten was a solar deity especially worshipped during the Amarna Period heresy as the sundisk and creation god.

Bastet was originally a fearsome lion and later also a benign and nurturing cat. Her cult had solar connections with the eye of Re. Bastet also personified the eastern cardinal point.

Bes was a grotesque, short and stout figure with leonine ears and ruff, exaggerated negroid mask-like facial features and extended tongue. He was a domestic deity who protected sleepers and women in childbirth and also women from the jealousies of other women.

Hathor was a mother goddess, associated with a celestial cow. Her head-dress included bovine horns and a sundisk. Hathor whose name literally means 'House of Horus' nurtured Horus, incarnate as king of Egypt. Isis, mother of Horus, was assimilated with Hathor so that it is sometimes difficult to distinguish between them. Hathor was also the mistress of joy, dance, music and love.

Heqet was a female frog deity and midwife.

Horus was the falcon deity born of Osiris and Isis. Horus gathered his father's dismembered body and vanquished his murderous uncle Seth. According to myth, wicked Seth had torn the eye of Horus to bits, but it was restored by Thoth. The healthy eye of Horus was also considered to be the eye of the sun.

Called the *wedjat*-eye, it was believed to ward off evil. The living Egyptian pharaoh was regarded as Horus incarnate. When the pharaoh died, he became Osiris. Horus could be shown as a child with a side-lock and often with his hand to his mouth, emphasizing his role as the son of Isis.

Imhotep, the legendary architect of the step pyramid of King Djoser at Saqqara, was later deified as a god of learning and medicine.

Isis was the mother of Horus and wife of Osiris. Her emblem of the royal throne as a crown was appropriately the hieroglyph which also spelt her name. Through her mourning for her murdered husband, Isis became associated with the dead. She and her sister Nephthys, together with Neith and Selket were a foursome who protected the dead and were often represented on the corners of coffins and funerary shrines. Isis' mothering qualities were assimilated with those of the wet nurse Hathor.

Kheper, the scarab beetle, pushed the early morning sun across the sky and so the scarab hieroglyph is also the ancient Egyptian word for the verb 'to come into being'.

Maat personified the concept of world order, justice and right. She sat on the prow of the sun bark to keep it on course as it crossed the sky. Her head-dress was the single ostrich feather. Together with Thoth, Maat was a guarantor of precision.

Meretseger, a snake goddess with an undulating tail, was a personification of the Theban necropolis where she dwelt. As such she protected both the dead and the professional necropolis workers who built the tombs and lived in quarters nearby.

Min was represented as a man enveloped in a sheath, meant to be an early hieroglyph of the body. Min's raised right arm held the royal flail and his lowered left arm held his erect phallus, emphasizing his predominant fertility aspect. He was associated with Amun (Min-Amun).

Mut was the divine consort of the god Amun, later assimilated with Sakhmet.

Nefertem, whose name means 'Atum is beautiful', was a creator god and personification of the lotus blossom on the nose of the sun god Re. He was associated with salves and sweet smelling oils. Nefertem was also the son of Ptah and Sakhmet and he became a ferocious defender of the dead and was

accorded an important place at their judgement. He is usually shown as a man, sometimes as a lion, but with a large lotus on his head.

Nekhbet was the vulture goddess who personified Upper Egypt and the southern cardinal point. She wore the Upper Egyptian or 'White Crown'. Nekhbet had cosmic connections as a goddess of the heavens, as the moon, and as the right eye of the sun god Re. She protected the newly born king, especially as he took the throne. **Neith** was the goddess who personified Lower Egypt and wore the Lower Egyptian or 'Red Crown'. Her name is also reinforced by this crown which, as a hieroglyph, has the sound value of her name. She was a hunter and warrior who aided man against his enemy. She was also thought to be the mother of the crocodile god Sobek. Neith personified the western cardinal point where the dead were buried, and was thus one of the four protector–goddesses of the dead.

Nephthys, sister of Isis, saved Osiris' body from putrefaction, and was thus one of the four protector-goddesses of the dead.

Nut was the sky goddess, who had been impregnated by the earth god Geb. She was also the sycamore tree goddess who provided comfort to the dead and their Ba-souls.

Osiris, husband to Isis and father of Horus, was murdered by his brother Seth and according to a later tradition, was dismembered and scattered throughout Egypt. Osiris was the funerary king and 'Foremost of the Westerners' because he ruled over the west where the Egyptians buried their dead. He was represented as a royal mummy holding a crook, for its pastoral associations, and a flail, perhaps a ruler's fly whisk. Osiris also had fertility associations based on a connection with grains.

Ptah was a creation deity and patron of craftsmen. He wore mummy wrappings and the close-fitting cap and straight beard of craftsmen and smiths. Creation was thought to occur through the word of Ptah, whose cult centre was at the city of Memphis. Ptah and his consort Sakhmet were the parents of Nefertem. He was also associated with Sokar and Osiris, gods of the Underworld, and later he was considered to be the father of the Apis bull and of the skilled Imhotep.

Re was the sun god who was also worshipped when he perched on the double mound of the horizon as Re-Harakhty.

Sakhmet was the avenging lion-headed goddess, who wore the sundisk as her attribute. By vanquishing foreign enemies, the reigning pharaoh was likened to the combative, fire-spitting Sakhmet. Her venomous fire connection resulted in her association with the royal uraeus cobra and thus as the eye of Re whose role was to combat the enemies of the sun. As the city of Thebes rose in power, the Egyptian priests decided that Mut, consort of the chief god Amun, should be given greater prominence and so she was assimilated with the powerful and popular Sakhmet.

Selket was a scorpion goddess and one of the four protector–goddesses of the dead.

Seth was the inimical deity who murdered his brother Osiris and was identified with many animals.

Sobek was the crocodile god, and son of Neith.

Sokar, a falcon god, was an underworld deity also assimilated with Osiris (Sokar–Osiris) as gate keeper of the city of the dead.

Sons of Horus, there were four: Amset, shown as a man, physically protected the liver and spiritually the *Ka*-spirit; Hapi, the baboon, physically protected the lungs and spiritually the heart; Duamutef, the jackal, physically protected the stomach, and spiritually the *Ba*-soul; Kebehsenef, the falcon, physically protected the intestines and spiritually the *Sa*-spirit.

Taweret was a composite deity, mainly a pregnant hippopotamus with post-natal breasts. She stood upright on leonine legs with the spine and tail of a crocodile, and had human arms terminating in leonine paws. She was a goddess of marriage, of child-rearing, and, as such, shared the traits and crown of the goddess Hathor. Taweret played a further function in the rebirth of the dead. According to another tradition, she held the inimical crocodile Seth so that Horus could slay it. Perhaps for this reason, her amulet was worn by children to prevent encounters with snakes and crocodiles.

Thoth was the intelligent god who reckoned sums and, therefore, the years that a pharaoh would rule. He was represented both as the ibis and the baboon. As the heart, or intelligence, of Re, he reckoned the additions and subtractions of the moon. A master of accuracy, Thoth was the patron of all scribes. His reckoning abilities resulted in his presence as scribe on the judgement day, when the deceased's heart was weighed against the 'feather of Maat (truth)'.

Uraeus, the uraeus cobra was the quintessential royal Egyptian symbol, worn above the king's brow. The uraeus evokes a mythology and symbolism of its own, apart from the king. The uraeus was the eye of Re and of Horus, snatched by Seth. Once restored to Horus, it was likened to one of his crowns, both the Upper and Lower Egyptian Crowns being analogous to his two eyes. The uraeus is, therefore, symbolic of Egypt and of the rightfully restored Egyptian cosmos. According to another myth, the sun god sent out his eye and while his children searched for it, another grew in its place. To appease the anger of the original eye upon its return, the sun god gave it a special place on his forehead. Thus the uraeus is both the symbol of dominion over the Two Lands (Egypt) and the Eye of the Sun.

Wadjit was the cobra-goddess and personification of Lower Egypt and the northern cardinal point.

MOULDED ANIMAL VASE

-

E.G.A.4330.1943
Pottery. Height 14.8 cm, length 16.8 cm.
Naqada II (middle), 4000–3000 BC.
Given by R. G. Gayer-Anderson.

Archaeologists rely on pottery of all cultures for insights into ancient manufacture, trade, burial habits and chronology. It is therefore rewarding to be confronted by a pot which is also sculptural. This vessel has been realised in the form of a hedgehog, an animal which has always captivated the hearts of children and adults.

The hedgehog was certainly venerated in ancient Egypt, though we do not know its hieroglyphic name. It often figured in desert landscape scenes, and small sculptures of the animal were included in private tombs. Perhaps due to its resistence to poisons, the hedgehog was popular as an amulet in the Late Period, but the lack of inscriptions makes this difficult to corroborate.

This Predynastic vessel predates the introduction of the potter's wheel, and it ultimately derives its shape from stone squat jar prototypes with flanged rim and tubular lug handles. Here, rim handles, face, feet and rear were applied separately to the jar. The face, with deep eyes under a pronounced ridge, snubbed nose and mouth with lips, is amusingly skewed. Although this object functioned as a vessel, its additional animal form was intended to be evocative of the hedgehog and its qualities, and was perhaps included among the furnishings of a grave.

Further reading Bourriau, *Pottery*, cat. no. 40; V. von Droste zu Hülshoff, *Der Igel im alten Ägypten* (Hildesheim, 1980).

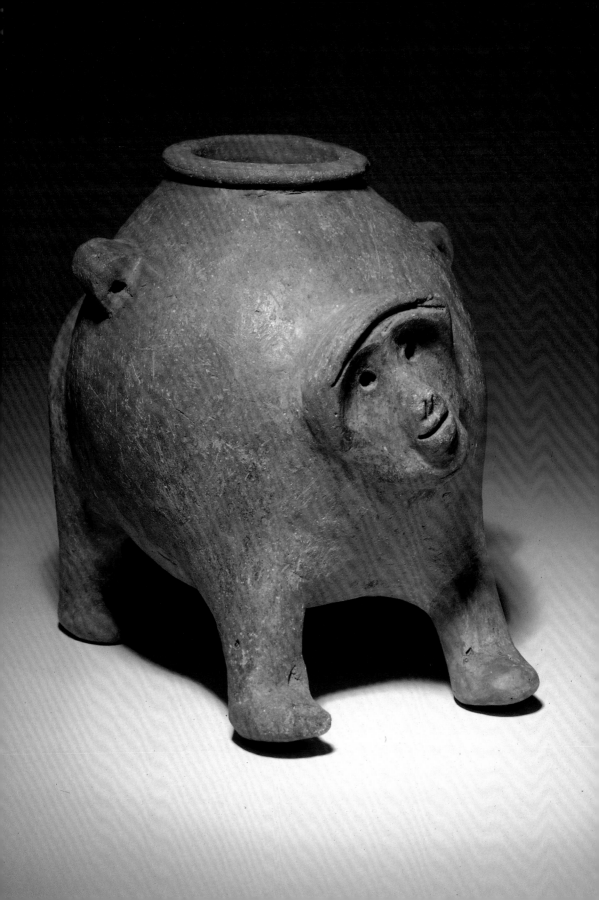

OBJECTS FROM THE
HIERAKONPOLIS TEMPLE DEPOSIT

—

E.85.1898 *Limestone triple hanging jar. Height 8 cm, width 13 cm.* E.18.1898
Faience scorpion. E.11.1898 *Serpentine scorpion.* E.10.1898 *Limestone dwarf with
penis sheath.* E.21.1898 *Faience vase on stand.* E.121.1898 *Porphyry disk macehead.*
E.13.1898 *Serpentine vessel with bull-headed lugs.* E.20.1898 *Calcite wavy handled
vessel.* E.32.1898 *Pink limestone pear-shaped macehead.* E.103.1898 *Serpentine
boat-shaped vessel.* E.24.1898 *Calcite thick-walled bowl with percussion hammered
inscription showing the inverted Ka-sign over the 'r' or t-sign and a falcon.* E.9.1898
Serpentine hanging bird vase. E.143. 1900 *Calcite bowl inscribed with inverted
Ka-sign over the 'r' or t-sign and a scorpion. Naqada II–Naqada III,
4000–3000* BC. *Given by the Egyptian Research Account.*

Egypt, in antiquity, was thought to encompass two lands: Upper and Lower
Egypt. Hierakonpolis, the city of the falcon god Horus, was the southern capital
and its primacy in the Predynastic Period is evident from excavations at the
site. The earliest temple at Hierakonpolis produced deposit finds of Narmer,
the first Egyptian king (between 3200 and 3000 BC).

The objects here came from the 'main deposit' of the Hierakonpolis Temple.
Many of the antiquities were already a thousand years old when they were buried
as the temple was being rebuilt.

This small sample from the deposit is composed of figures and vessels in a
variety of materials. Vessels range from simple bowls with the earliest royal name
of King Scorpion, local predecessor of Narmer and of Iry-Hor a contemporary,
to a boat-shaped dish and jars with bovine or serpent lugs and the bird and
triple vessel shapes. The exceedingly hard stone disk and pear-shaped maceheads
and a miniature example in faience, a precurser of glass, remind us of the
magical protective importance of weapons in a votive context. Most surprising
is the limestone figure of a dwarf, a novelty in ancient Egypt, and one of the
earliest known dwarf figures. The figurines of scorpions, one in faience, may refer
to King Scorpion or simply be meant as protection from this dangerous creature.

Further reading For Hierakonpolis, see LÄ, II, 1182–1186; J. E. Quibell, *Hierakonpolis*, I
(London, 1900); J. E. Quibell and F. W. Green, *Hierakonpolis*, II (London, 1902); B. Adams
Ancient Hierakonpolis (London, 1974) and *Ancient Hierakonpolis Supplement* (London, 1974).
A. J. Spencer, *Early Egypt* (London, 1993); J. Crowfoot Payne, *Catalogue of the Predynastic
Egyptian Collection in the Ashmolean Museum* (Oxford, 1993); for Iry-Hor see T. A. H.
Wilkinson in *JEA*, 79 (1993), 241–243.

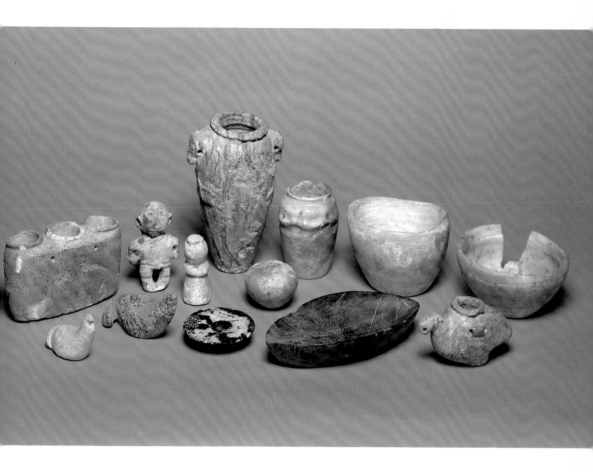

LION GAMING PIECES

—

E.4.1927 Ivory lion. Height 7.1 cm, width 4.8 cm. E.5.1927 Ivory lioness.
Height 7 cm, width 3.6 cm. Dynasty I, reign of King Djet, between 2920 and 2770 BC.
From Abydos, tomb 1560s. Given by the British School of Archaeology in Egypt.

Abydos in Upper Egypt rose to prominence in the late Predynastic and early Dynastic Period and a temple was built there to the god Khenty- amentiu, later identified with Osiris, Lord of the Afterworld. Rich dedications from kings of Dynasty I to the end of the Old Kingdom were made at Abydos. In the Middle and New Kingdoms the god's temple was successively rebuilt on a grander scale. It was thought that Osiris himself was buried at the site and kings also built themselves cenotaphs there. Abydos thus became a place of public pilgrimage and votive dedications. Officials' tombs were built nearby and the site of the royal necropolis became so crowded with pottery dedications that it recently became known by the local people as Umm el-Qab, 'Mother of Pots'. Sir Flinders Petrie excavated many of the royal tombs of Dynasty I and identified some of the kings with those named in the lists drawn up millennia later such as the ones from the reigns of Sethos I and Ramesses II inscribed at Abydos (1294–1213 BC) and recorded by the historian Manetho (about 304–246 BC).

These two ivory lions, once used as gaming pieces, are thought to come from the tomb of an official of King Djet, the fourth king of Dynasty I (between 3200–3000 BC). They represent an African male with a mane, and a lioness with a short ruff and an embroidered guilloche collar. Such gaming pieces prompted the suggestion that actual female lions were possibly tamed and used as decoys in the lion hunt.

These exquisitely modelled ivory lions repose with tail curled over the haunch corresponding to the preferred rightward orientation of the lion hieroglyph. The naturalistic modelling of these felines differs enormously from large and small contemporary hard stone images shown with fierce open muzzle, but blurred body forms. Hardness of material cannot account for the sculptural discrepancies. Small stone spheroids were also associated with some of the sets of lion and lioness ivory gaming pieces which have been excavated.

Further reading W. M. Flinders Petrie *et al.*, *Tombs of the Courtiers* (London, 1925), pp. 6–7, pl. VII, 2, 1; for Abydos, see LÄ, I, 28–42; for a survey of early dynastic lions see Whitney Davis, 'An Early Dynastic Lion in the Museum of Fine Arts', in *Studies in Ancient Egypt, the Aegean, and the Sudan; Essays in Honor of Dows Dunham*, eds. W.K. Simpson, W. M. Davis (Boston, 1981), pp. 34–42; B. Adams and R. Jaeschke, *The Koptos Lions, Contributions in Anthropology and History*, 3 (Milwaukee, 1984).

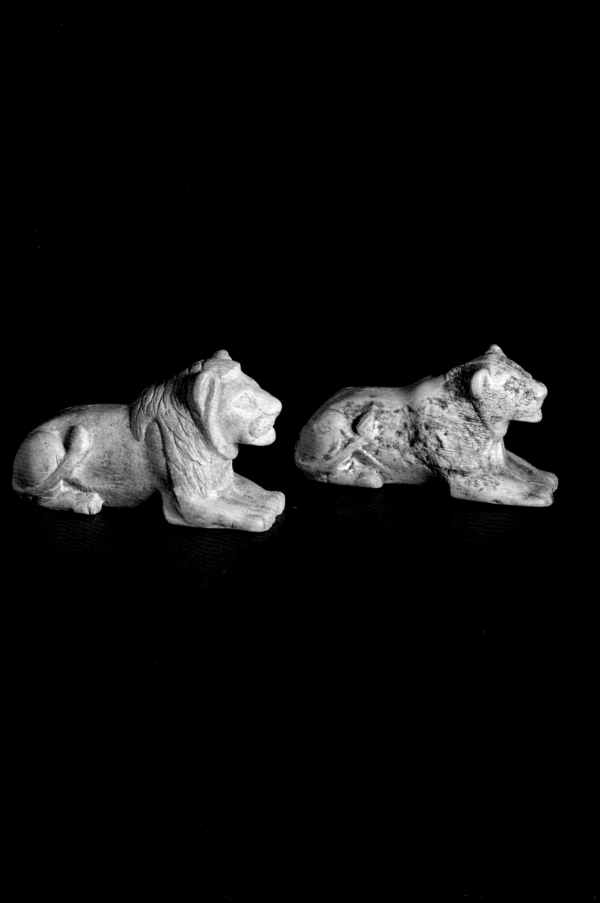

4

EARLY DYNASTIC STONE VESSELS

—

E.136.1954 Pink limestone footed bowl. Height 7.1 cm, diameter 6.8 cm.
E.110. 1954 Volcanic ash beaker. Height 12.6 cm. E.84.1954 Volcanic ash small
spouted bowl. Height 3 cm, width 6 cm. E.9.1950 Volcanic ash spouted bowl. Height
8.5 cm, diameter 13.8 cm. E.259.1954 Calcite bowl with undulating lip. Height 4 cm,
diameter 11.5 cm, Dynasty II. E.92.1954 Pink limestone footed jug. Height 14 cm,
diameter 7.4 cm, Naqada III. E.111.1954 Volcanic ash jug. Height 12.2 cm,
Dynasty I. All Naqada III – Dynasty II, between 3000 and 2649 BC.
All, except E.9.1950, bequeathed by Sir Robert Greg.

The contemporary eye runs the risk of attributing a modern sense of design to
the ancient Egyptian craftsman, and this selection of vessels reflects both high
technical achievement and a developed aesthetic ideal. Possibly then, as now,
form followed function so that distinctively shaped vessels held specific con-
tents in religious rites and everyday life. The eggshell thin walls, and in some
cases the raised foot, indicate that the aesthetics of form could be more mean-
ingful to artisan and consumer than sturdy construction. Included in this group
is a very rare bowl with an undulating lip meant to recall the lotus flower, a
symbol of Lower Egypt.

Stone vessels were made in the Nile Valley as early as the fourth millen-
nium BC, first by chipping a block into rough shape and then probably by hol-
lowing it out with the use of a hand-cranked drill. This, according to later
representations, was composed of a piece of wood weighted at the top with
two stones tied to it, with a borer, probably of flint, slotted into its base. Sand
could be added as an abrasive and in time copper drills possibly supplanted the
flint ones. The outer surface of the vessel was polished by hand with an abrasive
and oil. This laborious handwork allowed the artisan to concentrate on his design,
undaunted by the hardness of his medium.

Further reading A. El-Khouli, *Egyptian Stone Vessels: Predynastic Period to Dynasty III*, 3 vols.
(Mainz am Rhein, 1978); J. Crowfoot Payne, *Catalogue of the Predynastic Egyptian Collection
in the Ashmolean Museum* (Oxford, 1993), pp. 131–145; B. G. Aston, *Ancient Egyptian Stone
Vessels: materials and forms* (Heidelburg, 1994).

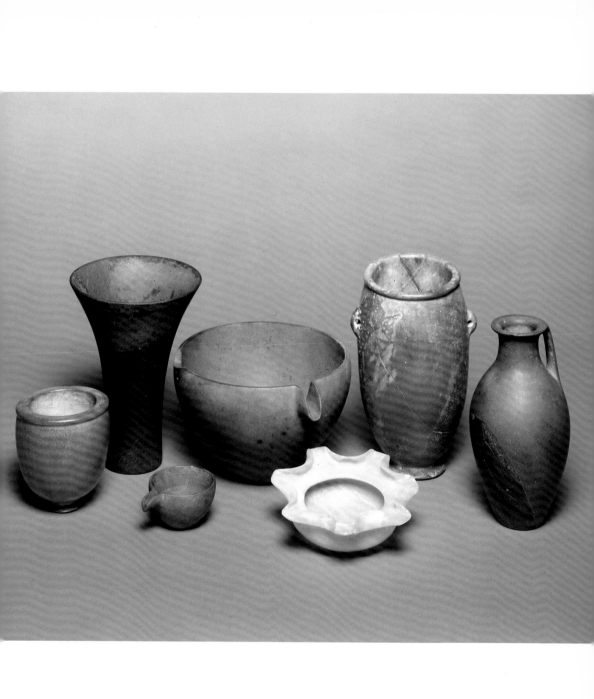

5

FOREIGN CAPTIVE

—

E.5.1972
Limestone, once plastered and painted.
Height 11.2 cm. Old Kingdom, Dynasty III (?), 2630–2611 BC.
Purchased through the University Purchase Fund.

The ancient Egyptians believed that the king regulated the cosmos and guaranteed the Ordered World, which was Egypt. Indeed, it was believed that beyond the borders of Egypt chaos reigned. The nine traditional foreign races were to be vanquished, and thus an imagery was developed in the late Predynastic Period on commemorative palettes. Foreigners, distinguished by their full beards (Libyans, Palestinians) or African features (Nubians), were depicted being gored by a lion or bull – a metaphor for the king – or being smitten by the king with a mace. By the time of the Old Kingdom (2575–2134 BC) foreigners were depicted bound with heads thrust up and their faces contorted by pain on the bases of thrones, on royal thresholds and the like, so that the king could metaphorically trample them underfoot.

In this small figurine a captive Libyan is shown on his knees with his elbows bound behind his back. His race is distinguished by the high forehead and cheekbones, long hair and full beard. His anguish is even more apparent from the rear view where his feet, possibly broken, are horizontally positioned under the weight of his body. Perhaps this accounts for the axis of his body which is pitched forward at the waist, in an attempt to relieve the weight on the feet and lessen his agony. The remains of a tenon on the head suggests that the figure formed an ornamental device on a piece of furnishing, possibly along the plinth of a throne. The fact that the figure is fully modelled from the rear view might also suggest that this enemy was to be viewed from both views.

Further reading Hayes, *Scepter*, I, pp. 113ff.; J. E. Quibell, *Hierakonpolis*, I (London, 1900), pls. XI, XXIX.

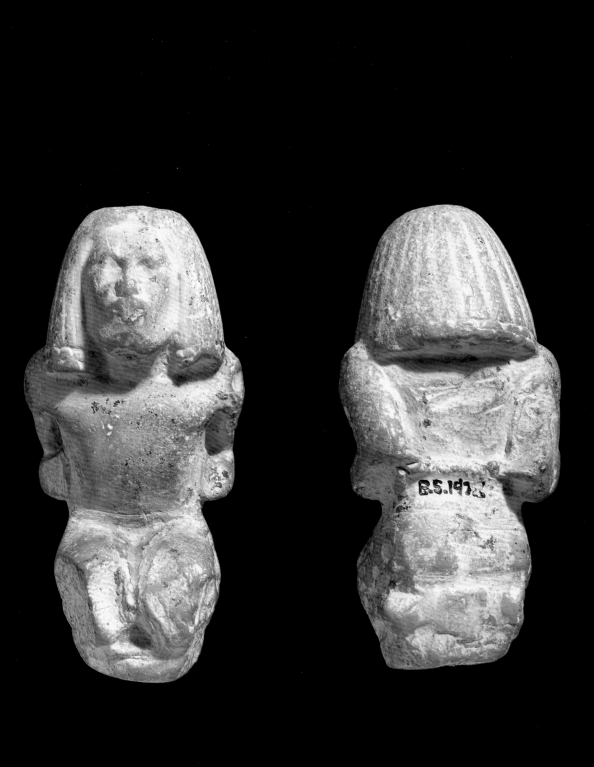

INTKAES AND HER DAUGHTERS

◦

E.7.1909 *Limestone with traces of plaster. Height 76 cm, width 48 cm.*
Old Kingdom, late Dynasty V – early VI, 2480–2255 BC. *Probably from Giza.*

Intkaes was a priestess of the goddesses Hathor and Neith (see nos. 30, 32, 51), deities respectively of love and beauty, and of war and hunting. Both were venerated at Memphis, the Old Kingdom capital of Egypt, south of Cairo. It is likely that Intkaes lived in this region. She is shown in raised relief facing four of her daughters, Henutsen, Niankhbastet, Nikauhathor and Niankhhathor, and all are dressed in tunics of fine linen with wide shoulder straps, long wigs and jewellery at the throat and wrists. Two daughters have names incorporating that of the goddess Hathor, indicating Intkaes' devotion to that deity. Her youngest daughter, Neferpesez, still a child, is shown naked with her natural hair pulled to the right into a side lock. She stands behind her mother diffidently clasping her leg.

The unrealistic scale, which makes the most important figure, Intkaes, the largest, and the least important, Neferpesez, the smallest, combined with the absence of perspective, are two of the most characteristic features of Egyptian relief sculpture. The disparity between the figures is further emphasized by the inscription above the head of the main figure. The female depictions here are really oversized hieroglyphs, and can be read as part of the inscriptions. They have no independent identity apart from their texts which provide only personal names and the titles of Intkaes. We can assume that this fine relief came from a large tomb commemorating the whole family, which stood in one of the cemeteries of Memphis that stretch for some thirty miles southward from Giza, on the outskirts of Cairo.

It is evident from the lack of detail in the depiction of the jewellery and the absence of plaiting of the hair on the daughters that the relief was hastily finished, with the texts at the top in sunk relief (note the names of the daughters at the bottom of the stele in raised relief) and with incomplete borders. This suggests that the artisans carved the scene first and finished the texts at the top last in a less labour-intensive sunk relief. Features such as the broad shoulders and long torso, the lowered hip on the far side of the body and the implausibly twisted wrists of the lowered arms date this relief to the late Old Kingdom.

J. B.

Further reading N. Strudwick, 'A Slab of 'Int-k3s in the Fitzwilliam Museum', JEA, 73 (1987), 200–202, pl. XIII; Smith, HESPOK.

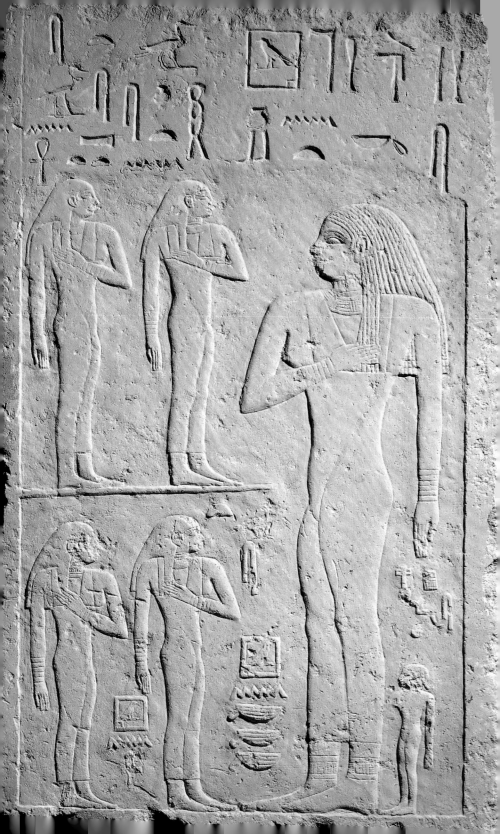

HEMI-RE, PRIESTESS OF HATHOR

—

E.6.1909 Limestone with traces of pigment. Height 82.5 cm, width 63.5 cm.
First Intermediate Period, 2134–1982 BC. Probably from Busiris in the Delta.

The 'false door' is so-called because its design incorporates the lintels and jambs of a real door. The patterns of the moulding simulate the bound reed bundles customarily fixed for strengthening purposes at the corners of primitive dwellings and early temples. It was built into the western wall of the tomb chapel at the point where it was believed that the worlds of the living and the dead could meet. Through it, the spirit or Ka of the dead person – in this case Hemi-Re – could come to receive the food offerings placed before it and hear the prayers needed to nourish her soul through eternity. The surface of the door is covered in sunk relief with prayers and invocations, including an appeal to passers-by: 'As for all people who will say "Bread to Hemi in this her tomb": I am a potent spirit and will not allow it to go ill with them.'

In a raised relief panel above the lintel Hemi-Re is shown seated before a table of offerings. Sunk representations of Hemi-Re terminate the end of each column of hieroglyphic inscription on the sides of the stele. She is shown both as a girl with her hair drawn into a long pigtail ending in a disk, a hair style already out of fashion, and as an old woman with pendulous breasts shown from the front, not in profile as convention normally demanded.

No mention is made in the inscriptions of Hemi-Re's husband, children or parents, but they may have been commemorated in other parts of the tomb which have not survived. The funeral monument of Hemi-Re is of considerable historical importance, since Busiris, its alleged findspot, lies in the centre of the Delta on the Damietta branch of the Nile. Scarcely any excavations have taken place there. In antiquity Busiris was one of the most important religious centres in Egypt. It was associated especially with the worship of Osiris, King of the Dead, who is commonly called Lord of Busiris. This 'false door' also mentions the goddess Hathor, Lady of Busiris, whom Hemi-Re served, and whose cult in that city is not known from any other source.

The hieroglyphs are uneven and towards the bottom of the relief they are crowded. The attenuation and angularity of the figures, rendered more marked by the deep contours and suspension of the figures over uneven base lines are charming features of the art of this politically unstable period. J.B.

Further reading H. G. Fischer, 'Some Early Monuments from Busiris in the Egyptian Delta', *Metropolitan Museum of Art Journal*, 11 (1976), 5–24; Smith, HESPOK.

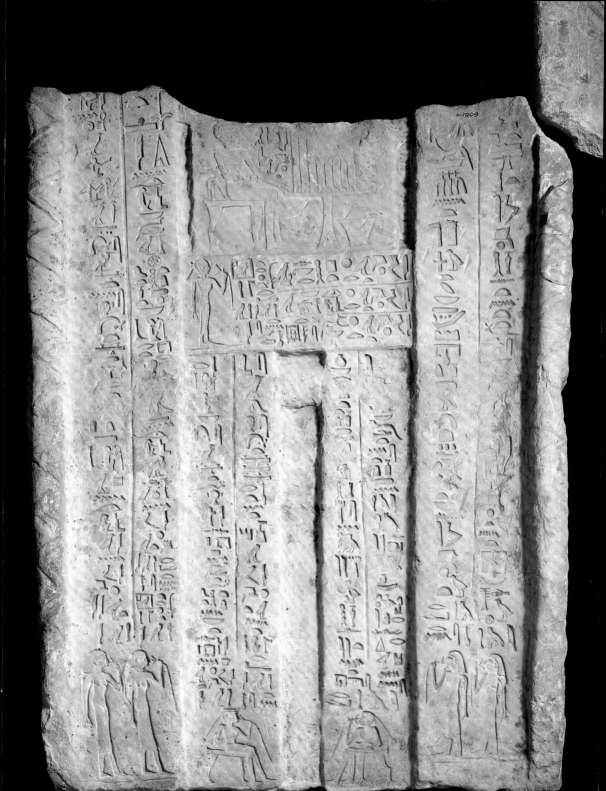

KING NEBHEPETRE
MENTUHOTEP

E.G.A.3143.1943 Limestone.
Height 12.2 cm, width 17.1 cm. Middle Kingdom,
Dynasty XI, early in the king's reign, about 2040–2021 BC.
Given by R. G. Gayer-Anderson.

The reign of Nebhepetre Mentuhotep (2033–1982 BC) was a turning point in Egyptian history, noted by his contemporaries and by successor kings just as it is by modern scholars. His statues and monuments were never defaced or usurped and he was venerated as the initiator of a new and powerful line of kings. When he came to the throne, he ruled only over Thebes and the neighbouring area. The first nineteen years of his reign were spent making his claim to be 'the Lord of the Two Lands, King of Upper and Lower Egypt', a reality. Thereafter and for the next three hundred years Egypt remained a strong and unified kingdom.

This fine fragment of limestone sunk relief shows the head of the king and part of his feather crown, and perhaps flail sceptre. The crown is composed of a double plume of falcon feathers stuck into a close fitting helmet which was taken over by Nebhepetre from the regalia of the god Amun, who was still a relatively minor deity, local to Thebes. Indeed as the association was so close, this may be an image of the god in the prevalent style of the reign. As light falls on this deeply cut sunk relief it provides a pleasing contrast between smooth, rounded surfaces (cheeks, neck and helmet) and the lines of narrow, precise raised relief delineating eye, brow, ear, nose and mouth. This elegant, mannered style is distinctive for the early part of the king's reign, before he reunified the country.

Apart from his great mortuary temple at Thebes many of the king's monuments are now represented by only a few blocks of masonry, preserved by their casual reuse in the walls or foundations of later buildings. This fragment cannot be assigned to a particular building, though its style is closest to the Hathor chapel which the king built at Dendera early in his reign. J. B.

Further reading *Bourriau, Pharaohs, cat. no. 2.*

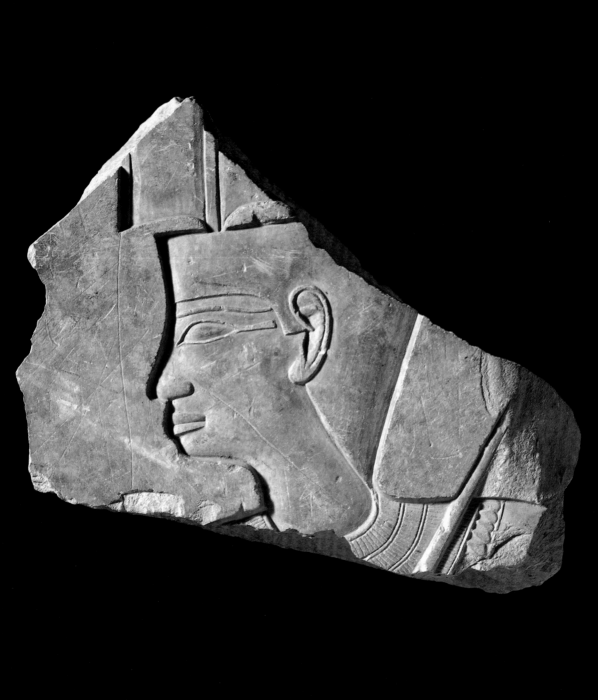

STATUETTE FRAGMENT
OF A MAN

—

E.41.1937 *Painted wood.*
Height 12.4 cm, width 5.6 cm.
Middle Kingdom, Dynasty XII, reigns of
Amenemhat I to early Senwosret I, 1991–1962 BC.
Bequeathed by C. S. Ricketts and C. H. Shannon.

Wood was not very plentiful in Egypt, so sculptures were often constructed from disparate pieces, pegged together. Although far less durable than stone, wood offered certain advantages in that a sculpture did not require the support of a back pillar or a filler between the legs, usual in the more static stone sculptures. In addition, the left arm of the striding male figure could be bent to grip a staff for a life-like effect indicating forward movement. Wooden figures were usually gessoed and painted, and often other materials were inlaid into the eye-sockets for a lifelike effect.

The male owner of this bust wears a short plaited and shaped wig which bulges above his ears. Facial details are indicated in black paint and the outer corners of the eyes are elegantly enhanced with a painted cosmetic stripe, as was customary for both men and women. Pads of flesh are subtly indicated above a naso-labial or 'smile' furrow, and at the corners of the broad mouth. The man's arms were separately attached, and the wooden dowel pins are still in place. The shape of the wig and the straight eye-brows, which ignore the contour of the eye orbits, the emphatic tear ducts (see no. 10) are all details which date this figure to the beginning of Dynasty XII.

Whereas female images could be placed in male tombs as companions and servants, this image of a man, possibly an official, and of modest means (judging from the scale) was probably placed in his own tomb or in a chamber within a family tomb complex. In this period the tendency was for royal and divine images to be set up in temples, whereas nobles' and lesser individuals' monuments were strictly funerary.

Further reading Vandier, *Manuel* III, chapter 3.

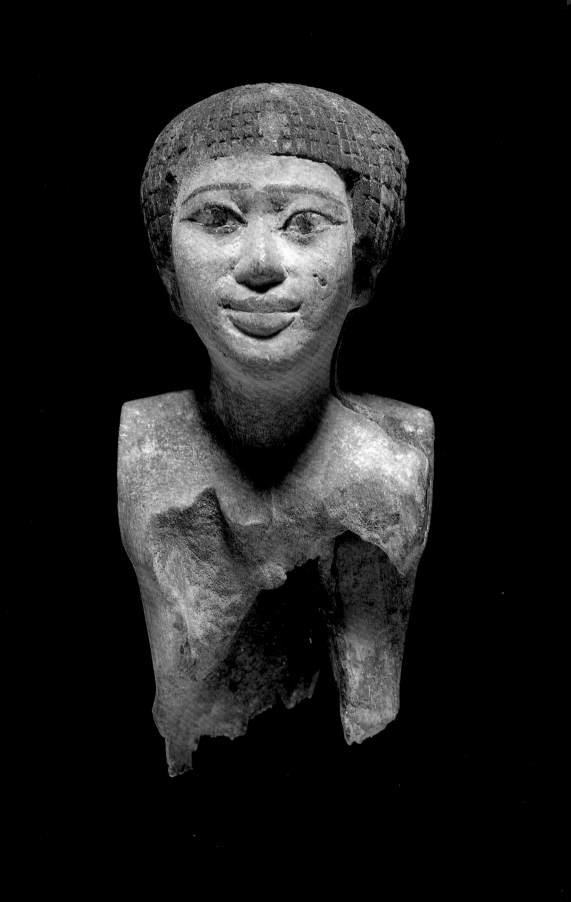

STATUETTE FRAGMENT OF A WOMAN

E.1.1989
Painted wood with inlays in ebony, copper,
obsidian and alabaster. Height 15.3 cm, width 6.6 cm.
Middle Kingdom, Dynasty XII, reign of Amenemhat I to
early Senwosret I, 1991–1962 BC. Possibly from Thebes.
Given by the Friends of the Fitzwilliam Museum.

By the greatest good fortune the termites that destroyed the body spared the
face and one breast of this remarkable statuette, one of the most beautiful
wooden sculptures to survive from the Middle Kingdom. Its quality suggests
that it was made by a highly skilled, probably royal, craftsman.

The woman is anonymous and the place and circumstances of the dis-
covery of her statuette remain unknown. The fragment came to England from
Egypt in the 1930s, set into a bed of coarse lime plaster to prevent it from dis-
integrating. The plaster was removed in the Museum conservation laboratories,
revealing the figure's compelling, though fragile beauty.

The original statuette would have stood on a wooden base inscribed
with the lady's name and titles. Part of her long wig is visible above her breast
and was essentially the same as that worn by Intkaes (no. 6). The long wig, the
quality of the work and the fine materials used for the inlays of eye and brows
are indications of her high rank. The shape and proportions of her features,
especially the long elegant ears, the almost straight brows set over large,
slanting eyes with exaggerated tear ducts, point to a date early in Dynasty XII.
The best parallels suggest the early part of the reign of King Senwosret I, per-
haps during his ten year co-regency with his father Amenemhat I. J.B.

Further reading Vandier, *Manuel* III, chapter 3.

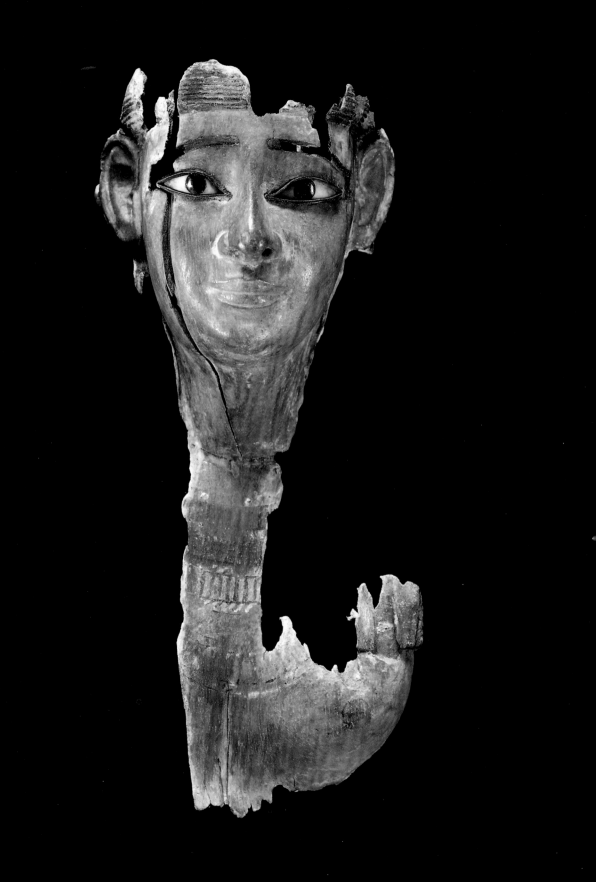

KING SENWOSRET III

E.37.1930 Pink granite.
Height 32.3 cm, width 34.0 cm.
Middle Kingdom, Dynasty XII, reign of Senwosret III,
1878–1843 BC. Given by F. W. Green.

The king's battered face does not reveal itself easily to the onlooker from this monumental head. Nose and ears are almost totally destroyed and the subtle contours of the face are lost without a strong raking light. The commanding eyes and the grim mouth first claim attention, and their expressiveness contrasts starkly with the idealised features of the earlier King Nebhepetre Mentuhotep (no. 8). This change must reflect a conscious decision by the king to incorporate his features into his public image, thereby breaking with tradition. The workshop which produced the statue was certainly capable of capturing this awesome expression of a human being wielding superhuman powers.

The head is carved in pink granite, one of the most intractable of materials, chosen for statues of the king precisely because of its qualities of endurance. The sculptor has mastered his medium and has represented a complex structure of flesh and bone. Despite the damage, the sensitivity in the carving can be seen in the pouches under the eyes and in the pads of flesh around the mouth.

Senwosret III was an extraordinary ruler, his reign was a major turning point in the Middle Kingdom. It was the climax of a process by which the king re-established his authority throughout Egypt, reducing the power of local families who had effectively ruled the provinces since the end of the Old Kingdom. Art, literature, royal and private monumental architecture, burial customs as well as the method of government itself all underwent a distinct change of direction during his reign. J.B.

Further reading Bourriau, *Pharaohs*, cat. no. 28; Vandier, *Manuel* III, pp. 188ff.

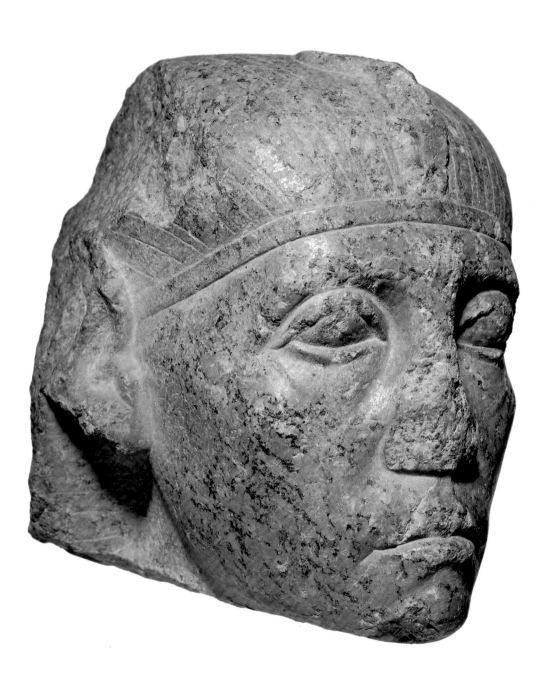

KING AMENEMHAT III

—

E.2.1946 Dark fossiliferous limestone.
Height 11.6 cm, width 14.3 cm. Middle Kingdom,
Dynasty XII, reign of Amenemhat III, 1842–1797 BC.
From Aswan. Bequeathed by Oscar Raphael.

The Fitzwilliam Museum is fortunate in possessing two masterly portraits of Egyptian kings, one of Senwosret III (no. 11) and the other of his son Amenemhat III. They can be compared, feature by feature, and the same sculptors may have worked for both Kings. It is revealing to see the limestone material and the miniature scale of this head invite intimacy, unlike the grandeur of the colossal granite head of Senwosret III. The variegated colour of the pale fossils embedded in the greenish-grey limestone contrasts with the dark veins in the granite head of the other figure.

The king wears the *nemes*-headcloth made of striped linen, and wears a curled uraeus cobra on his brow, a token of his divinity and kingship. The sculptor, exploiting the soft stone to the full, has produced a most sensitive portrait which emphasizes the bone-structure of the face underlying the contours of the flesh. Amenemhat III's reign of over forty years was the climax of the stable and powerful Dynasty XII. He is shown here as a young man, on the threshold of middle age, an idealism retained in portraits throughout his reign, though few are of this quality.

The head came from a small seated statue of the king and was excavated from a tomb at Aswan by Lord Grenfell in 1886 during recreation from his duties as Commander-in-chief of the British garrison in Egypt. J.B.

Further reading Bourriau, *Pharaohs*, cat. no. 28; Vandier, *Manuel* III, pp. 195ff.

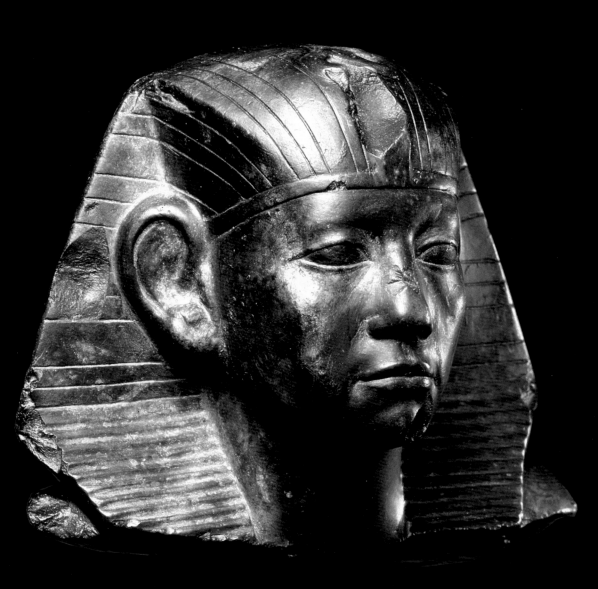

THE SOLDIER KHNEMU

—

E.500.1932 Basalt statuette.
Height 18.6 cm, width 7 cm. Middle Kingdom,
Dynasty XII reign of Amenemhat III – early Dynasty XIII,
1842–1730 BC. Possibly from the region of Asyut.
Given by the Friends of the Fitzwilliam Museum.

The lower part of the legs and the feet are missing from the statuette but this hardly matters since the sculptor has ensured all our attention is focused on Khnemu's powerful head and torso. The long enveloping kilt provides a surface for an inscription framed by the arms and hands, which are in the traditional attitude of reverence before the gods. By contrast, the prominent musculature of chest and upper arms give the impression of controlled energy.

The features of the face reflect the physiognomy of the kings Senwosret III (eyes, mouth and contoured brow (no. 11)) and his son Amenemhat III (ears, nose and square face (no. 12)) of whom Khnemu was probably a contemporary. Khnemu's large ears are set very high and pushed forward by his trapezoidal wig, typical of the period. The powerful modelling is contrasted by the inscription which is surprisingly crude: at least three of the hieroglyphs were recut over an earlier hammered-out inscription.

The statuette's provenance can only be suggested by a study of the style and inscriptions. The facial type, wig, modelling of the torso, long kilt and attitude suggest a date late in Dynasty XII or early in Dynasty XIII. Khnemu's father's name, Nemtyemhat, means 'Nemty is foremost', Nemty being the name of an obscure falcon god, the patron of travellers, whose name is written with a pictogram of a bird standing on a boat. In Dynasty XIII there was a shrine of Nemty at el-Abawla, which lies on the right bank of the Nile, five miles south of Asyut in Middle Egypt. A close parallel, now in the Cairo Museum, was bought at Asyut in 1901 and may suggest a provenance for the present figure. Men and women frequently incorporated the names of local gods into their personal names (see no. 6) and deposited small statues of themselves in local shrines as votive offerings. It was a method of involving the deity and the worshippers at his shrine in the maintenance of their personal funerary cult. J.B.

Further reading Bourriau, *Pharaohs*, cat. no. 42; Vandier, *Manuel* III, pp. 248ff.

THE SOLDIER USERHAT

—

E.88.1903
Wooden coffin, plastered and painted.
Height 33.2 cm, width 41.2 cm. Middle Kingdom,
mid-Dynasty XII, 1878–1843 BC. From Beni Hasan,
tomb 132. Given by the Egypt Exploration Fund.

This coffin of the soldier Userhat shows an idealised face with features following the contemporary sculptural style which in turn was based on the portraits of kings like Senwosret III and Amenemhat III (see nos. 11, 12). The names of other members of Userhat's family have not been preserved, but we know that he was buried and, presumably, lived at Beni Hasan, roughly half way between Cairo and Luxor. His tomb was excavated by John Garstang in 1903, and contained only Userhat's two coffins (the fine outer rectangular coffin is in the Museum of the School of Archaeology, Classics and Oriental Studies at the University of Liverpool) and some pottery. The inner coffin was found resting on its side, so that the head was aligned with the eyes painted on the exterior of the outer rectangular coffin.

The coffin imitates a human body wrapped for burial and wearing a funerary mask. However, the inscription shows that the older idea of the coffin as the protector of the fragile body was still retained. In the inscription, the coffin is identified with the sky goddess, Nut: 'Recitation: Oh Osiris, the soldier Userhat, your mother Nut, has spread herself over you'. The deceased Userhat is identified with the god Osiris, King of the Dead, marking a profound change in the status accorded to the non-royal dead from the Old Kingdom. The magical spells, objects and accompanying rites, previously reserved for the dead monarchs, were adopted for funerary use by private individuals from the end of the Old Kingdom. The invocation to Nut, for example, first appears in texts carved inside the royal pyramids of the Old Kingdom. Userhat wears a beard, previously worn exclusively by kings or gods. His face, like that of Osiris, is painted black, the colour of the fertile soil of Egypt, thus symbolizing rebirth and resurrection. J. B.

Further reading Bourriau, *Pharaohs*, cat. nos. 71, 72; Hayes, Scepter, I, pp. 309ff.

MOURNING WOMAN

E.283a.1900
Painted wood fragment from a coffin.
Height 39.3 cm, length 116.5 cm. Middle Kingdom,
late Dynasty XII–XIII, 1862–1648 BC. From Abydos, E. 281.
Given by the Egyptian Research Account.

This painting affords us a rare glimpse of the principal mourner in a funeral procession of the late Middle Kingdom. She is bent over, holding her hands against her breast in a pose natural to someone suffering intense physical pain and grief. Her cheek is stained with tears, and her face is framed by her long hair; her hands are clasped. She may be a professional mourner, or an unnamed close relative of the dead. The pose expresses emotion, but the drawing, in contrast, is controlled and angular and neatly positioned into the overall composition of the procession painted on the long side of this rectangular coffin fragment. In front of the woman are two men carrying the poles which may have supported the coffin itself. Funerary subjects are rarely depicted in Middle Kingdom tombs, but a few other coffins showing similar scenes have survived. J.B.

Further reading Bourriau, *Pharaohs*, cat. no. 75.

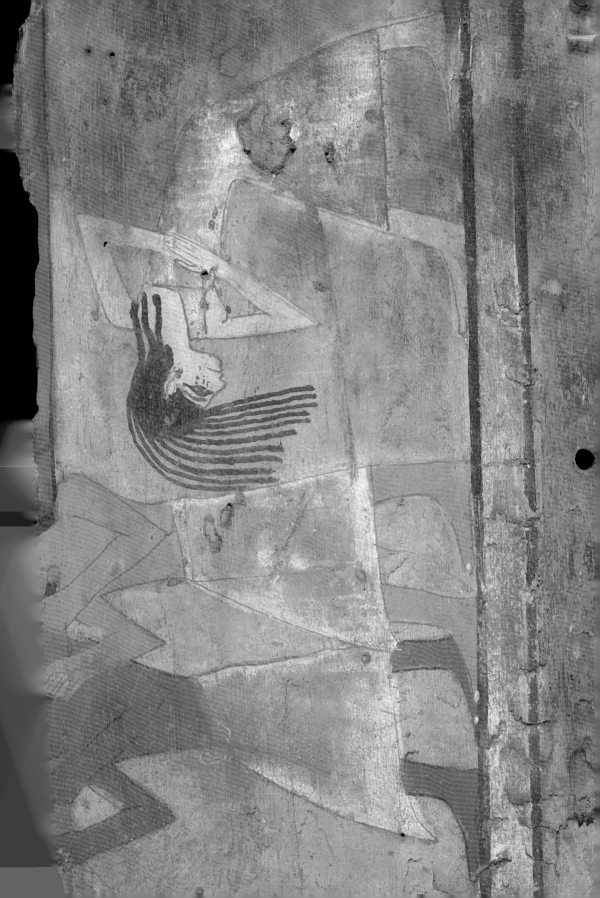

HEDGEHOG AND JERBOA

—

E.345.1954 and E.279.1939
Turquoise blue faience with details in black.
White faience with details in brown. Hedgehog: height 3.8 cm,
length 6.3 cm. Jerboa: height 4.1 cm, width 2.7 cm. Middle Kingdom,
Dynasty XII–XIII, 1963–1648 BC. From Beni Hasan and Heliopolis.
Bequeathed by Sir Robert Greg and given by G.D. Hornblower.

A miniature menagerie of animals in the form of figurines appear in some Middle Kingdom tombs. They are often denizens of the desert margins, like these two, or of the great river Nile – like hippopotami and crocodiles. Their precise purpose is not certain, but we presume that they had a part to play in the rites intended to protect the dead in their journey through the Underworld. A popular scene in decorated tombs shows the deceased hunting in the desert, where hedgehogs usually appear as part of the landscape. Such faience statuettes occur only in modest tombs without painted or carved wall decoration, and so perhaps these were intended to suggest by themselves the context of the hunt. This hedgehog comes from Beni Hasan, tomb 655, and may be dated by associated objects to Dynasty XII.

The jerboa comes from a tomb near Heliopolis which was discovered by local bedouin in 1913, and its contents sold. The companion pieces to the jerboa are now in the British Museum, the Metropolitan Museum of Art, New York and The Brooklyn Museum. The group may be dated somewhat later than the hedgehog, to late Dynasty XII–XIII.

The material known as faience was manufactured from the Predynastic period onwards (no. 2), but was much more finely developed in the Middle Kingdom. Essentially, faience is composed of a granular quartz which is fused with alkali and coloured with a blue–green copper compound or oxide of iron for black and reds. Objects could either be made in a mould, with further hand tooling in the case of sculpture, or thrown on a wheel in the case of vessels.

J. B.

Further reading Bourriau, Pharaohs, cat. nos. 110, 112; Hayes, Scepter, I, pp. 223ff.; Lucas, *Egyptian Materials*, pp. 155ff; A. Kaczmarczyk and R. E. M. Hedges, *Ancient Egyptian Faience* (Warminster, 1983); P. T. Nicholson, *Egyptian Faience and Glass*, Shire Egyptology, 19 (1993).

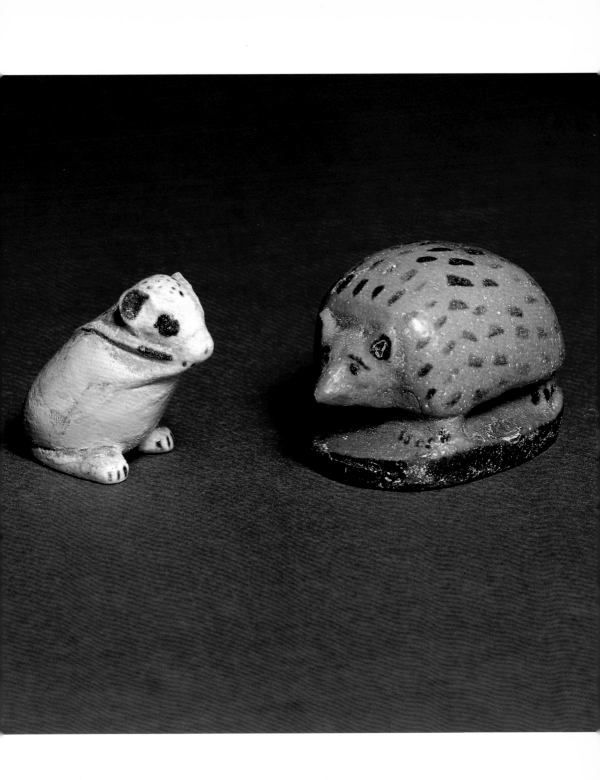

AMENEMHAT NEBUY AND HIS FAMILY

—

E.207. 1900 Painted limestone stele. Height 82.7 cm, width 66.5 cm.
Middle Kingdom, late Dynasty XII, 1842–1786 BC. From Abydos Tomb,
E.295. Given by the Egyptian Research Account.

Amenemhat Nebuy is shown on this stele in the presence of his immediate family and his servants. In the upper register he is seated before a table of offerings bearing joints of meat, fruit, bread and vegetables. Nebuy was 'steward of temple lands', but which temple he served is not known. This stele was set up in a cenotaph chapel at Abydos, a place of pilgrimage revered as the burial place of the god-king Osiris, but there is no evidence that Nebuy was actually buried there. Kneeling behind him are his mother, Nefert, and a lady called Seneb, probably his wife. In front of him are his brothers Seankh and Renefankh and a sister Rehutankh. Below the family, two servants bring offerings of meat and other foods. Nebuy was possibly childless, since it is his servant Renefseneb, rather than a son, who offers the foreleg of an ox to him – a symbol of perpetual foodstuffs. Children are also lacking on another stele in the Fitzwilliam Museum which commemorates the same family.

In the lower register the deceased is standing, grasping his staff of office and 'inspecting the abundant produce'. A procession of men bring ducks and geese, oxen and gazelle. These servants, of relative importance since each is identified by name, include two 'Asiatics'. This term was applied by Egyptians to the inhabitants of Sinai as well as those from Syria and Palestine. Joseph, well-known from the Old Testament, was an Asiatic from the Egyptian view-point, but there is no evidence on this stele or elsewhere that these men had a status different from their Egyptian counterparts. Archaeological evidence suggests that many of them entered Egypt voluntarily, eager to share in the prosperity of one of the richest countries in the ancient Near East.

The border of the stele is decorated with a rectangular pattern and the *khekher*-frieze at the top, which may imitate woven wall coverings. The rectangular shape of Middle Kingdom stelae is supplanted by a round-topped shape in the New Kingdom. Nebuy has included as many people as possible on his funerary stele, to ensure that the working unit of family and household should live with him in the Netherworld. He wished not only to guarantee an endless supply of food offerings, but also to preserve his role in society. J.B.

Further reading J. Garstang, El Arábah (London, 1901), pp. 33–34, pl. VI; Bourriau, *Pharaohs*, cat. no. 39; Hayes, *Scepter*, I, pp. 330ff.

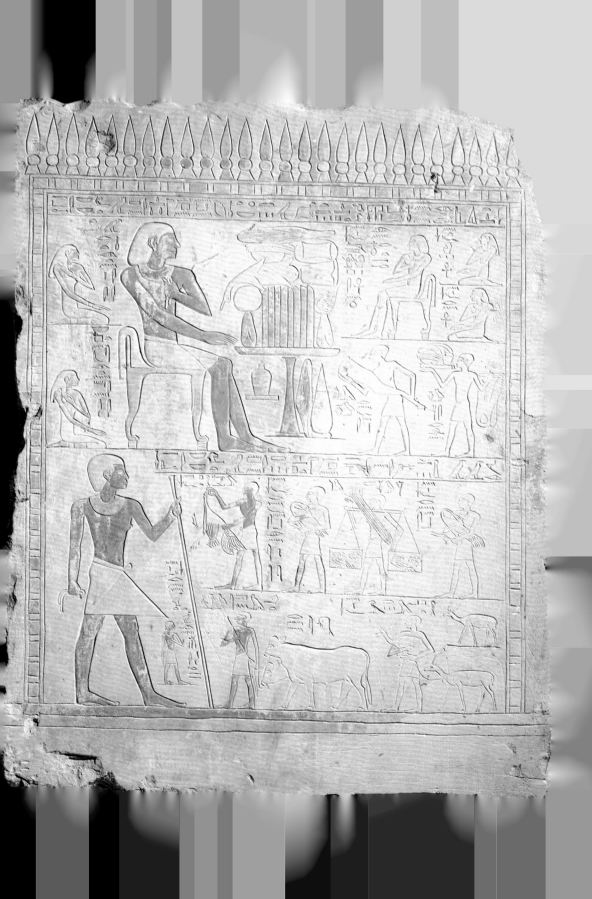

BOUND NAKED WOMAN

—

E.189.1939
Terracotta, handmade.
Height 12 cm. Middle Kingdom,
late Dynasty XII–XIII, 1862–1648 BC.
Given by G. D. Hornblower.

Knowing how the Egyptians valued ideal youth and beauty, and that a proportional grid was employed by artists to ensure consistency, we are loathe to accept as mainstream Egyptian a crude handmade terracotta figure which does not conform to traditional standards. However, many naked female figures with overtly prominent pubic triangles and decorative tattoos, though modelled cursorily in other aspects, do come from Egyptian funerary contexts.

The present figure has been pinched into shape by hand so that the back of the head is flat and the face is beaked. The mop of hair does not conform to any recognisable Egyptian style of wig, although it is deeply striated. Strokes for tattoos were scored on the shoulders at the back and front. The figure was not made to stand – her legs are angled, and remarkably her hands are bound behind her back.

Naked women are infrequently depicted in ancient Egyptian art, but when they are it is thought that they occur for magical reasons. To comprehend the significance of naked female figurines (naked males are rare) the idea of sex should be disassociated from the likely symbolic fertility function in the Afterlife. Some examples of abbreviated naked female figurines are shown holding an infant. Many similar images have been found in tombs belonging to men, women and children, and thus cannot be solely regarded as sexual playmates. The bound arms in this example however, is unexpected in an image of an Egyptian woman. This figure probably represents a captive woman used in some execration ritual against foreigners and their procreation.

Further reading For female fertility figures see W. M. Flinders Petrie, *Objects of Daily Use* (London, 1927), pp. 59–60, pl. LII; C. Desroches Noblecourt, BIFAO, 53 (1953), 34ff.; Hayes, *Scepter*, I, pp. 220–221; Bourriau, *Pharaohs*, cat. nos. 119–121. For execration figures, though wrongly identified as male, see G. Pinch, *Egyptian Magic* (London, 1994) pp. 90–95, fig. 49.

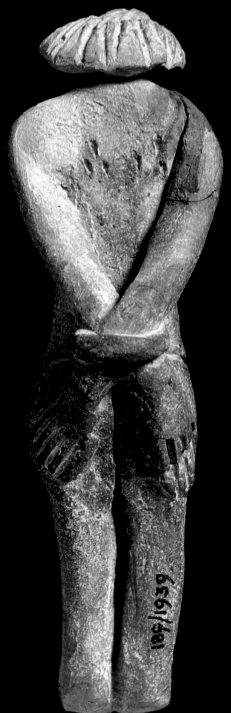

RELIEF OF THE QUEEN MOTHER

—

E.G.A. 3100.1943 *Limestone.*
Height 10 cm, width 13.2 cm. From Deir el-Bahri,
south wall of upper court of Hatshepsut mortuary temple.
New Kingdom, Dynasty XVIII, *reign of Queen Hatshepsut,*
1479–1457 BC. *Given by R. G. Gayer-Anderson.*

Although only a fragment, there is much to be gleaned from this raised relief of a royal lady, who wears a vulture head-dress and carries the lily sceptre. Egyptian figures may appear conventional at first glance but facial details on this relief, such as the arched and tapered eye-brow, almond shaped eye with incised upper lid and upturned nose, can be used by the art historian to date this figure to the reign of Queen Hatshepsut. She usurped the throne from her nephew Tuthmosis III who was still a minor, and became a female pharaoh. The royal lady represented here is Ahmose, mother of Queen Hatshepsut and consort of King Tuthmosis I.

In order to legitimize her rule, the usurper Hatshepsut designed an impressive funerary monument at Thebes, which was directly modelled on and situated next to that of the famed ruler and founder of the Middle Kingdom, Nebhepetre Mentuhotep (no. 8). In this colonnaded and terraced structure, Hatshepsut resorted to several narrative fictions to strengthen her position. In one scene, her mother Ahmose is shown associating with the god Amun, and in another she is led away to give birth to her divine daughter Hatshepsut. The present fragment comes from the upper court of the temple, where actual events are recorded. There colossal sculptures of both Hatshepsut and her father Tuthmosis I are shown on reliefs being towed down the Nile on barges.

This image of Ahmose, preceded by the larger image of her daughter Hatshepsut, still in its original position on the mortuary temple wall, was altered in antiquity. Originally, Ahmose wore a wig which obscured her ear and held a baton, rather than a lily sceptre. Wig and baton were later recarved into the royal vulture head-dress and lily sceptre. Other reliefs on lower terraces show an unaltered figure of Ahmose wearing the vulture head-dress, indicating that the artisans started work at the top of the structure and at some point corrected the earlier reliefs with the new royal attributes.

Further reading Myśliwiec, *Le Portrait*, p. 51 no. 23 (b), fig. 87; subsequently identified by J. Karkowski of the Polish Mission at Deir el-Bahri as part of block 141/72.

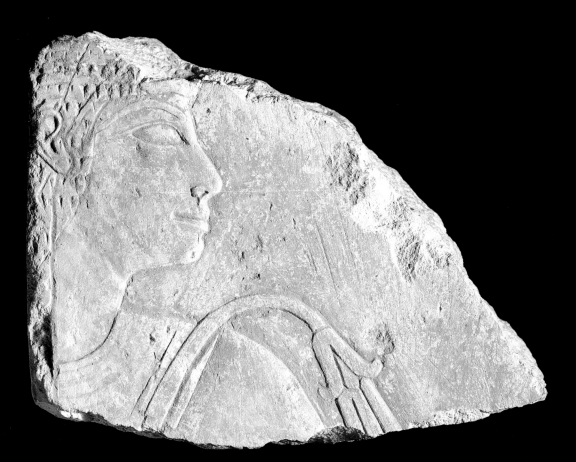

KEREM AND ABYKHY

—

E.21.1887 Painted limestone pair statue.
Height 40 cm, width 27.5 cm. New Kingdom,
Dynasty XVIII, early in reign of Tuthmosis III,
1465–1455 BC.From Thebes.

Neither Kerem nor his wife Abykhy were Egyptians. Their names represent an attempt to reproduce foreign, possibly Semitic, names in the hieroglyphic script, and so, unlike many Egyptian names, they have no meaning. Kerem, however, also acquired a good Egyptian name, carved in the funerary text on the back of this pair statue, 'Geregwaset' which means 'settled in Thebes'. The name itself suggests a newcomer, perhaps, an economic immigrant, but another possibility is that he was a prisoner of war, brought to Egypt after the Syrian campaigns of King Tuthmosis III.

Kerem was a scribe (perhaps bilingual) and door keeper of the chapel of the goddess Hathor in the mortuary temple which Tuthmosis III built into the rock adjacent to the temple of Queen Hatshepsut, (see no. 19) at Deir el-Bahri, on the west bank of the Nile at Thebes. He is shown holding a scribal palette, to reinforce his claim to scribal status in both this world and the next. Funerary inscriptions often include such a claim, with or without justification, to enable the deceased to avoid the rigours of manual labour which awaited the illiterate in the Afterlife.

Kerem and his wife, called his sister in the fashion of the New Kingdom, had five children, all bearing typical Egyptian names: four sons Qenamun, Meh, Simut, Nebneteru; and a daughter, Nebetiunet. They are shown in relief on either side of their parents' seat and, in the case of the daughter, beside her mother's leg. Abykhy herself is shown with her arm around her husband's waist.

It has been suggested recently that the sculpture came from a chapel dedicated to cults of members of the royal family of Tuthmosis I, which was discovered accidentally at Thebes in 1887 by children playing in the sand. J.B.

Further reading S. Quirke, 'Kerem in the Fitzwilliam Museum', JEA, 76 (1990), 170–174; Vandier, *Manuel* III, pp. 439ff.

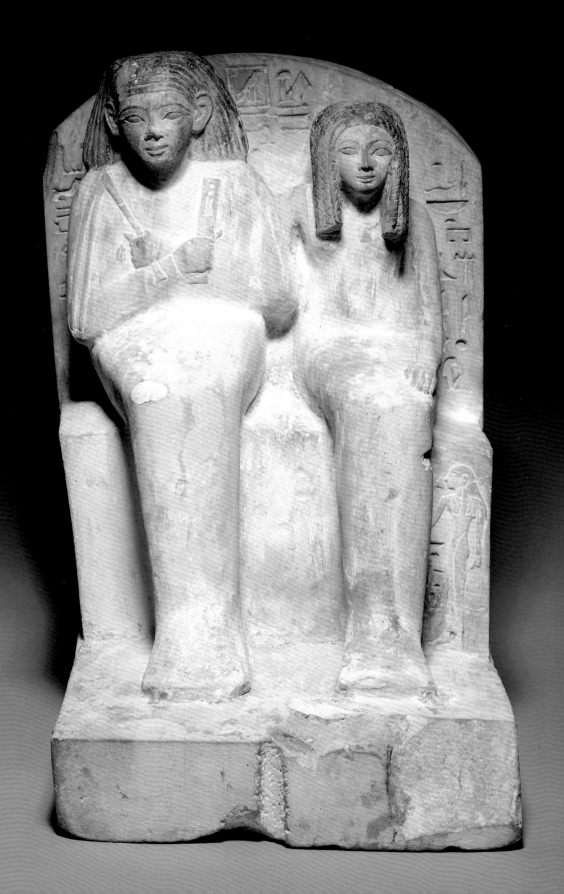

DYNASTY XVIII TOMB
GROUP OF AN EGYPTIAN LADY

—

E.22.1921 *Wooden box with bone applied decoration. Length 14 cm, width 11 cm.*
E.23–31.1921 *Glazed steatite scarabs.* E.32.1921 *Glass cowroid bead.* E.33.1921 *Carnelian frog.* E.34a–c.1921 *Carnelian scarabs.* E.2.1921 *Bronze knife.* E.1.1921 *Bronze mirror.* E.37.1921 *Serpentine rimless vase.* E.36.1921 *Calcite footed vessel.* E.21.1921 *Calcite bowl.* E.38.1921 *Calcite kohl pot with lid.* E.35.1921 *Faience bowl with black decoration.* E.20.1921 *Glazed steatite kohl pot with lid. From Sidmant el-Gebel, tomb group 1723. New Kingdom, Dynasty XVIII, reign of Tuthmosis III, 1479–1425 BC. Given by the British School of Archaeology.*

This tomb group comprises objects which an Egyptian lady deemed necessary for her journey to the Afterlife. Her ointments and kohl were in the small pots, the bowls were for washing, eating or in the case of the faience example, for ritual use on the journey, her knife probably for preparing food.

The jewellery is mainly composed of scarabs in glazed steatite, carnelian and glass and a carnelian frog. The ancient Egyptians noticed that the scarab beetle laid its eggs in dung which it then rolled along between its forelegs. The eggs hatched from the dung balls impelling the Egyptians to view this as autogenesis and rebirth. Kheper, the scarab, was thought to push the early morning sun across the sky and so the scarab hieroglyph meant 'to be' or 'to come into being'. The frog recalled both the creation deity that emanated from the mouth of Re, and thus was associated with the regular and necessary inundation of the Nile, and with the goddess Heqet, deity of childbirth. Even the mirrors can be interpreted in a symbolic way. The disk, cast in copper alloy, was red and bright and recalled the sun. It was sacred to the goddess Hathor, daughter of the sun god Re, and mother of mothers. Because the face was reflected in the disk, it was believed that as part of the grave goods the mirror revived the dead. The papyrus plant handle recalled the fertile wet Delta and symbolized growth and eternal youth. The faience lotiform decorated bowl completes the rebirth symbolism since the lotus plant closes at night, only to open up again in the morning.

Further reading W. M. Flinders Petrie and G. Brunton, *Sedment*, II (London, 1924), p. 26, pl. 63; C. M. Firth and B. Gunn, *Teti Pyramid Cemeteries*, I and II (Cairo, 1926), I pp. 69–70, II, pl. 44; Hayes, *Scepter*, II, pp. 193–197; Heqet: LÄ, II, 334–336; E. C. Strauss, *Die Nunschale – Eine Gefässgruppe des Neuen Reiches, Münchner Ägyptologische Studien*, 30 (1974); C. Lilyquist, *Egyptian Mirrors from the Earliest Times through the Middle Kingdom* (Berlin, 1979); Vandier d'Abbadie, *Objets de Toilette*; Bénédite, *Objets de Toilette*.

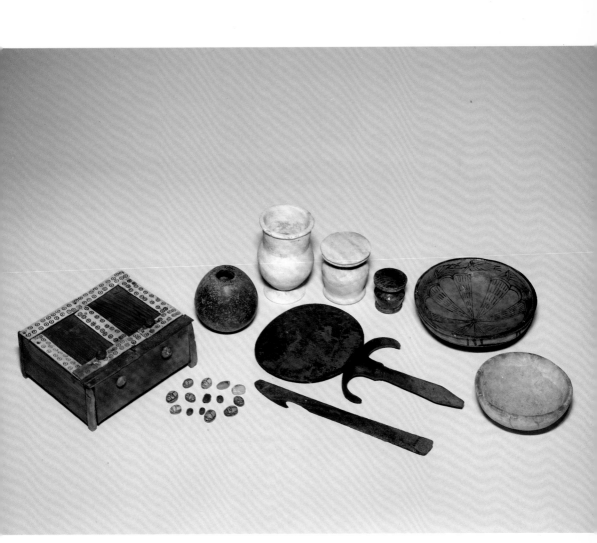

OBJECTS FROM THE BOUDOIR

—

E.112.1932 Glass palm-shaped kohl vessel with yellow and white trailing. Height 7 cm. E.1.1938 Glass palm-shaped kohl vessel with pale blue and white trailing. E.423.1932 Wood bouquet-shaped fan handle. Bequeathed by E. Towry Whyte. E.96.1937 Ivory bouquet-shaped fan handle. Bequeathed by C.S. Ricketts and C.H. Shannon. E.W.30 Wood and ivory multiple vessel. From Beni Hasan, tomb 287. E.153.1939 Ebony and ivory with kohl stick. Given by G. D. Hornblower. New Kingdom, Dynasty XVIII, 1391–1295 BC.

Every traveller to Egypt will be familiar with the burning sun and the flies which aim for the eyes. The Egyptians protected themselves from the sunlight by kohl under the eyes, whence the tradition of a cosmetic stripe from the corner of the eyes towards the ear. Kohl also protected them from the flies. Further protection from the heat and flies was achieved by wielding a fan or whisk.

In this group we have kohl containers and fan handles in a variety of precious materials. The most common kohl vessel in Egypt was palm shaped. In a country where trees were scarce, shade was mostly afforded by palm trees. The palm also produces nutritious dates and nuts, and the palm frond was an ideogram for the words 'year', 'season' and the verb 'to be young' or 'vigorous'. Glass technology was probably introduced from Western Asia in Dynasty XVIII. The palmiform kohl vessels were made by applying hot glass over a core of clay and dung, and then rolling the glass over a flat surface; the process was repeated several times for each vessel. Trail decoration was achieved by reheating and applying other glass colours to the surface and then dragging the trails up and down.

Imported wood and ivory were rare commodities suitable for small luxury items. The multiple wood kohl vessel whose lid is removed is decorated with ebony and ivory inlays. Perhaps each compartment held a different eye make-up such as kohl, malachite or iron ochre, etc. The ebony vessel has a pivoting lid and place for the kohl stick applicator, still in place.

The fan handles take the shape of bundles of lotus buds and blossoms. The lotus had developed a significance as the plant of Upper Egypt, and also as the place where the young sun god was reborn each morning. The ivory fan handle is considerably more stylized than the wood example.

Further reading Vandier d'Abbadie, *Objets de Toilette*; S. Goldstein, *Pre-Roman and Early Roman Glass in The Corning Museum of Glass* (Corning, 1979); Lucas, *Egyptian Materials*; Boston, *Egypt's Golden Age*; Bénédite, *Objets de Toilette*.

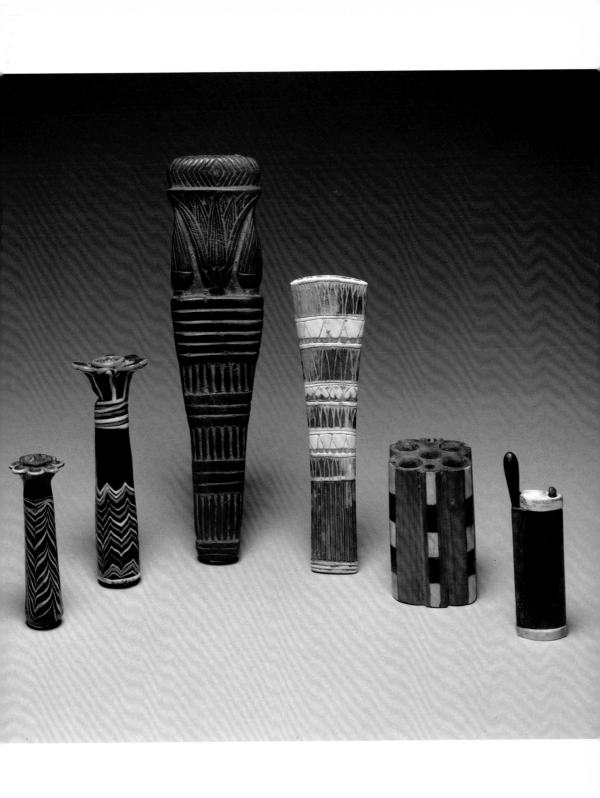

BRONZE HEAD OF A KING

—

E.G.A.4504.1943 Copper alloy. Height 4 cm.
New Kingdom, Dynasty XVIII, reign of Amenhotep III,
1391–1353 BC. Given by R. G. Gayer-Anderson.

Bronze was rarely used for royal representations, though it was common for votive images of deities which were mass produced in the sixth century BC. In this rare royal bronze head, the king wears the Blue Crown, thought to be a war helmet, which came into vogue during the New Kingdom. The youthful facial characteristics with the slanted eyes set far apart, the fleshy cheeks, the pierced ears and the circular coil of the cobra on the crown suggest King Amenhotep III (1391–1353 BC). His characteristic arched eye-brows and artificial cosmetic stripes on the cheeks are only faintly visible under a thick layer of corrosion.

Solid cast copper-alloy figures made from moulds appear in the First Intermediate Period (about 2134–1963 BC), then, in the Middle Kingdom (1843–1798 BC) hollow figural castings began to be made. Both processes coexisted into the Roman Period. Hollow castings were formed around a core that in the earlier periods only approximately followed the contours of the figure. The extremities such as the head and limbs were often solid, whereas the torso was hollow cast. Perhaps this was the case with this head. The break at the neck shows a thick corrosion layer which suggests that the head broke off the figure in antiquity.

Bronze figures did not proliferate in the New Kingdom and only two inscribed examples of kings of Dynasty XVIII are known, one solid and one hollow cast. It is not clear why bronze royal figures are rare from this period, since the casting technology had not been forgotten. Perhaps the fact that the technology enabled multiple images of the king to be reproduced, or that the metal could be reused by melting the figures, rendered bronze a less appealing medium. Bronze images, like those in wood, did however offer the advantage of freeing the negative spaces from between the limbs which had to be filled with connective material in stone sculptures. In any case, this head constitutes an important link in the history of ancient Egyptian bronze working technology.

Further reading E. Vassilika, 'Egyptian Bronze Sculpture Before the Late Period', *Chief of Seers: Egyptian Studies in Memory of Cyril Aldred* (London, forthcoming); The Cleveland Museum of Art, *The Art of Amenhotep III: Art Historical Analysis*, L. M. Berman ed. (Cleveland, 1990).

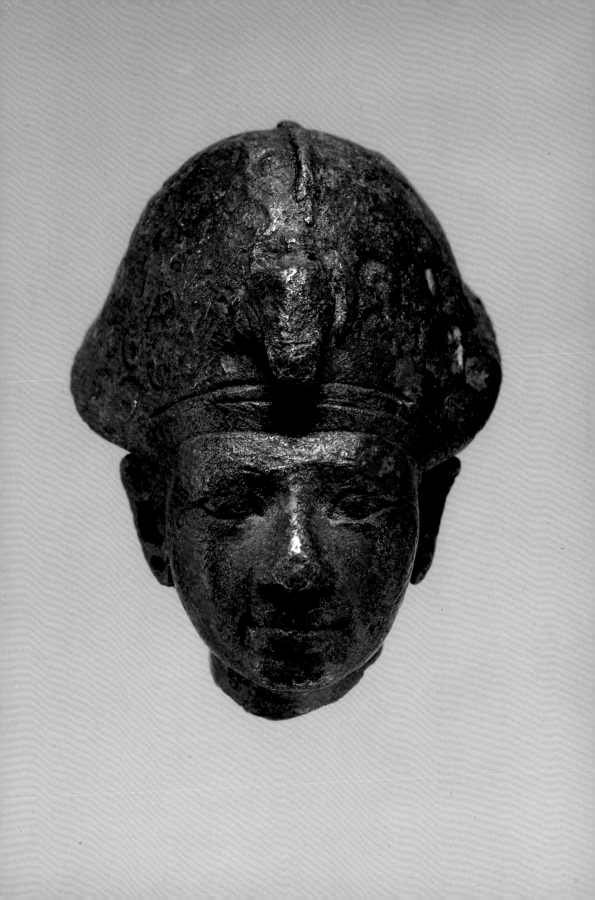

THE GOD BES

•

E.67a–c.1937 Wood. Height 11.4 cm.
E.68.1937 Ivory. Height 11.4 cm. New Kingdom,
Dynasty XVIII, reign of Amenhotep III, 1391–1353 BC.
Bequeathed by C. S. Ricketts and C. H. Shannon.

The deity Bes played an important role in the Egyptian pantheon. He was a grotesque, short and stout figure with leonine ears and ruff, exaggerated negroid mask-like facial features and extended tongue. The pygmy-like arms rest on flexed thighs, a distended phallus, or a feline tail, are shown between the legs. The god's crown is composed of the tail feathers of an ostrich, here visually interpreted to resemble a lotus.

Bes was a deity affording protection during the night, and was especially important against snakes. In addition, he was connected with Hathor and her hippopotamus manifestation (no. 61) in the protection of both women in childbirth and their newborn babies. His breasts could metaphorically provide their first drink. Bes also protected women from the jealousies of other females, and is thus known as the god of the boudoir. For all these reasons Bes was represented on bedroom furniture such as beds, head-rests and stools, as well as cosmetic boxes, eye make-up containers, mirrors and other similar objects. In addition, he had the ability to appease the temper of Hathor by music making and dance, and thus is represented either on musical instruments or holding them. He was also associated with drink and drunkeness, and was often shown on drinking vessels.

These fearsome looking Bes figures formed an open-work frieze, probably on a piece of furniture. The presence of at least two different artisan's hands may indicate a large object such as a bed. The stylized rib cage and the mode of modelling the eye-brows over the furrowed brow have firm parallels in representations of Bes dated to Dynasty XVIII.

Further reading Boston, *Egypt's Golden Age*, cat. nos. 46–49; LÄ, I, 720–724.

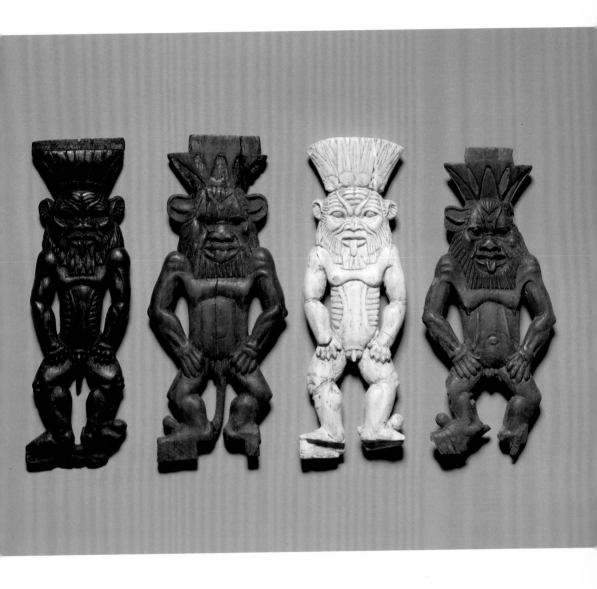

HAND-HELD
SHELL

—

E.429.1982 Slate.
Height 15.6 cm, width 5.8 cm.
New Kingdom, mid-late Dynasty XVIII,
1391–1295 BC. Given by the Trustees
of the Wellcome Foundation Limited.

The ancient Egyptians were fond of transforming naturally occurring forms in organic materials into objects of daily use. Thus a mussel shell was ideally suited to serve as the bowl of a spoon. Its only natural inadequacy lies in its lack of a grip. To circumvent this the Egyptians had a ready motif, the human hand, which they appended to all sorts of objects. Here the beautifully delineated hand is carved onto the back of the shell. The thumb is correctly shown with the nail in profile view. The wrist is decorated with a wristlet composed of long tubular beads. The undulating contour of the mussel is evident on one face of the object, on which it most probably rested when set down. Here we appreciate the aesthetics of the Egyptians who took the trouble to decorate the underside of an object with the utmost care.

Mussels were collected for the most part from the Red Sea, and their shells were worn as jewellery and amulets from the Predynastic Period. By the Middle Kingdom the shell shape was replicated in other more precious materials for jewels, and the shells themselves were used more mundanely as inkwells or they were cut up and used as an inlay material.

The size of this spoon suggests that it was probably used for mixing eye make-up. Like other examples in a variety of materials, it probably dates to Dynasty XVIII when toilet objects of great beauty and ingenuity proliferated.

Further reading Boston, *Egypt's Golden Age*, cat. no. 250; LÄ, IV, 228–230.

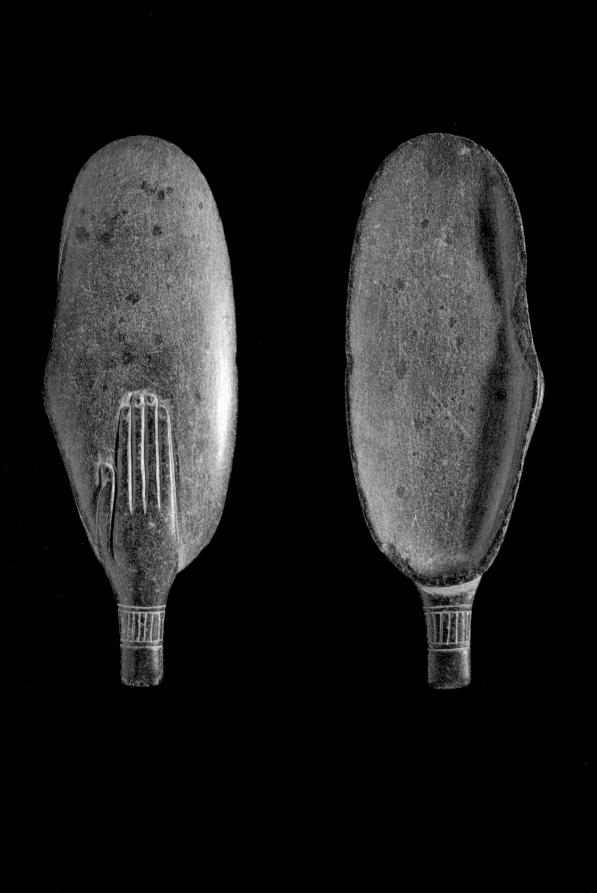

RELIEF OF THE HERETIC
KING AKHENATEN

E.G.A.2300.1943 Limestone. Dimensions: 23 cm × 53 cm × 5.5 cm.
New Kingdom, Dynasty XVIII, Amarna Period, reign of Akhenaten,
1353–1337 BC. Given by R. G. Gayer-Anderson.

Akhenaten (1353–1337 BC), son of Amenhotep III (no. 23) dispensed with the pantheon of Egyptian gods and worshipped only the Aten sundisk. This heresy resulted in his move to a new city called Akhetaten, modern el-Amarna. The Amarna Period, known for artistic innovations, takes its name from the site.

In this limestone sunk relief, King Akhenaten is shown twice. At the left he stands wearing the White Crown and a festival cloak, his arms upraised, before an offering table laden with foodstuffs and vessels. The sun's rays, terminating in hands, reach the king and his offering. A small-scale image of the king is on the other side of the table, perhaps a sculpture of the king in the distance. The text informs us that this scene takes place in the House of Rejoicing. A wide vertical band, possibly a wall or a door, separates this discrete moment from the next when the king stands or walks in procession dressed in a festival cloak, carrying the royal flail and crook and showered by the sun's rays in the form of *ankh-* and *was*-signs, representing life and endurance. He is flanked by his chief prophet bearing sandals and by his lector priest holding a papyrus roll. These priests bow at the waist, an unexpected departure in the repertoire of Egyptian gestures, but characteristic of the Amarna Period.

The relief demonstrates that even Akhenaten wished to celebrate the traditional royal *heb sed*-festival. The block was once thought so improbable for the period that it was believed to pre-date the heresy, before the king changed his name to one incorporating the name of the sun god. Re-examination of the block, however, does not support this interpretation. The block shows the mannered Amarna style promoted by the royal workshop: attenuation and angularity of the figures and the distinctive royal facial features which are thrust well forward of the neck. The elongation of the eye and the egg-shape of the fan-bearer's head are common details of the time, as are the sketchy and uneven depths of contour and the incised hieroglyphs unframed by any borders.

Further reading F. LL. Griffith, 'The Jubilee of Akhenaton', JEA, 5 (1918), 61–63, pl. 8; Griffith, JEA, 8 (1922), 199ff.; Aldred, *Akhenaten/Nefertiti*, cat. no. 11; C. Aldred, *Akhenaten* (London, 1988); J. Gohary, *Akhenaten's Sed-Festival at Karnak* (London and New York, 1992).

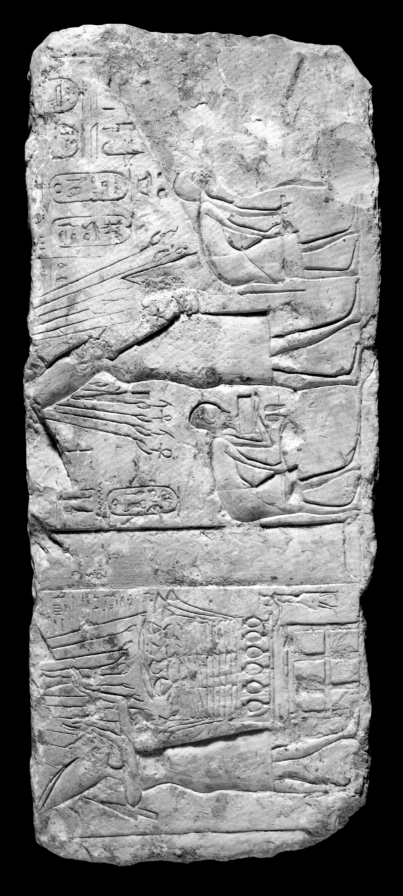

A ROYAL EMBRACE

E.G.A.4606.1943

Carnelian. Dimensions: 5.7 cm × 3.8 cm × 0.6 cm.

New Kingdom, Dynasty XVIII, Amarna Period, reign of Akhenaten,

1353–1337 BC. *Given by R. G. Gayer-Anderson.*

In this unfinished open-work plaque, we see the contours of the sundisk-worshipping king Akhenaten embracing and kissing his wife Nefertiti. The intimate couple are flanked by young daughters, embraced by a free parental arm. In a rigorous theocratic society where the pharaoh was divine, such scenes were unknown before the time of Akhenaten. His religious cult was unorthodox, as was his preferred mode of artistic representation. In Akhenaten's new cult, the royal couple worshipped the sun directly and in turn bestowed its beneficence on man. Since art served the king, representations of the royal family proliferated. The king chose to be shown with effeminate breasts, a high waist and thick thighs wearing long robes, in non-traditional poses, with the added naturalistic detail of the streamer at the back of his neck fluttering in the wind. These basic contours are represented here.

Intimate contact and kissing were almost never represented in ancient Egypt, either in private tombs, or royal scenes. However, Akhenaten and Nefertiti were shown kissing in scenes carved on stelae at el-Amarna, suggesting that they were publicly affectionate, and that they approved of this image. In a country where the traditional representational ideal was slender youth in decorous poses, the orthodox priests of the proscribed deities must have viewed such scenes with disdain, and as a symbol of royal excess.

This is one of the largest known semi-precious worked stones from ancient Egypt. Perhaps it was meant to be mounted in gold as a sizeable, presumably royal, pectoral. The fact that the royal crowns and one daughter's wig have been hollowed out, suggests that the artisan meant to detail them in another more precious material such as sheet gold. The crack at the bottom of the stone may have forced the craftsman to leave his work unfinished. We are fortunate that the piece has remained intact and was not cut into smaller pieces for reuse.

Further reading Aldred, *Akhenaten/Nefertiti*, cat. no. 123; C. Aldred, *Akhenaten* (London, 1988).

HEAD OF AN AMARNA PRINCESS

—

E.G.A.4524.1943 Shelly limestone head.
Height 20.8 cm, width 17 cm. New Kingdom,
Dynasty XVIII, Amarna Period, Years 6–8 of Akhenaten,
about 1347–1345 BC. From el-Amarna.
Given by R. G. Gayer-Anderson.

The coarse texture of the surface, the emphatic curves and hollows and the unfinished eyes give this sculpture a remote, abstract quality which appeals directly to twentieth-century taste. The princess represented was a daughter of King Akhenaten and Queen Nefertiti. The face of her mother, Nefertiti, is one of the most celebrated of any person who lived in antiquity, due to her famous and beautiful bust exhibited in the Egyptian Museum in Berlin. In profile the family resemblance is strong, especially in the shape of brows, nose and mouth. The gold mask from the tomb of Tutankhamun shares the same traits. The elongated shape of the head is a feature of representations of the Amarna Period, and was possibly achieved by binding at infancy.

This head comes from a group of statues of the royal family which were carved out of a soft limestone full of fossils. The fossils are harder than their limestone matrix, and centuries of abrasion by sun, wind and sand have produced a 'pock-marked' surface. The left hand side of the mouth shows a misguided modern attempt at cosmetic recutting to remove the pitting.

It is thought that the head comes from one of the monuments carved in the cliffs surrounding el-Amarna by royal command between Year 6 and Year 8 of Akhenaten's reign to mark the boundaries of the new capital. The royal children were represented constantly in the temples and palaces of this new city, but only fragments of their sculptures remain. The sun-worshipping religion survived Akhenaten's death by only a few years. The return to traditional practices resulted in the deliberate and systematic destruction of Akhenaten's city. None of the boundary stelae have survived intact and only one provides a possible location for this head. J.B.

Further reading The attribution of the head to Stela U at Amarna is due to the work of William Murnane and C. C. Van Siclen III, *The Boundary Stelae of Akhenaten* (London, 1993). The primary publication of the stelae is N. de G. Davies, *The Rock Tombs of El Amarna Pt V: Smaller Tombs and Boundary Stelae* (London, 1908), p. 27, pls. XXV, XXXIV, XXXVII.

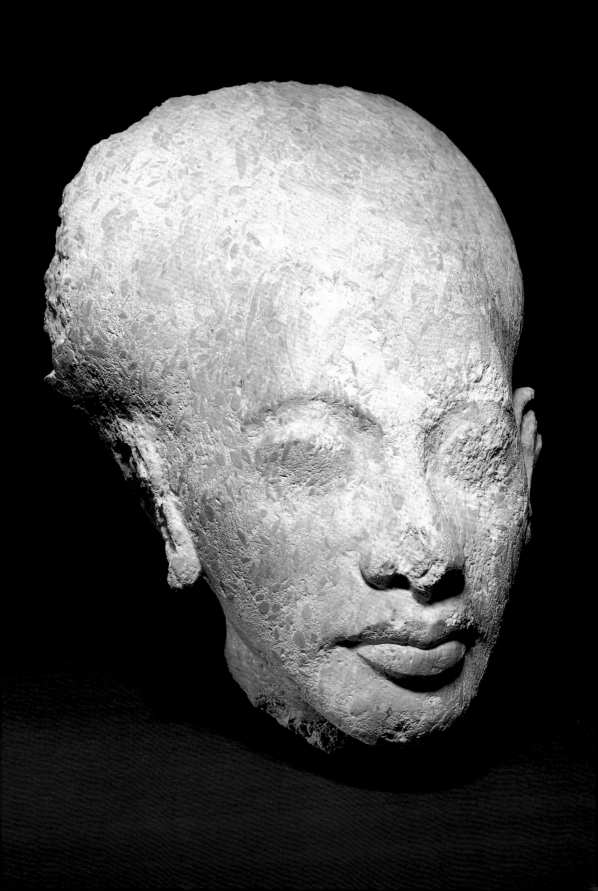

AMARNA RELIEF OF SOLDIERS

•

E.G.A.4514.1943 Limestone. Dimensions: 17.5 cm × 25 cm × 6 cm.
New Kingdom, Dynasty XVIII, Amarna Period, reign of Akhenaten,
1353–1337 BC. Given by R. G. Gayer-Anderson.

The Amarna Period is traditionally thought of as a time when military preoc-
cupation was suspended while king and court devoted themselves to the new
cult. However, written documents and representational evidence (such as this
relief) indicate that the Egyptian military establishment held firm throughout.

In this military relief scene we see how the Amarna artisans experimented
and challenged traditional representational conventions. Two soldiers moving
to the right, one armed with spear and axe and a shield slung over his near
shoulder, the other with shield under his arm and a rope in his near hand, are
both pitched forward at the waist, the second more markedly than the first in
apparent great haste. The men are depicted with large heads, sharply sloping
foreheads, but horizontal and centrally positioned eyes whose lids are sculpted
naturalistically and without the artificial rims and cosmetic stripes previously
represented. The jaws jut out prominently, and all the features follow the icon-
ography of the royal family (no. 26). The size of the vertically held heads equals the
breadth of the shoulders, the waist is sculpted high at the midriff and the limbs
are thin. Gawkiness is emphasized by the deep but uneven contours. All these
artistic mannerisms are characteristic of the Amarna style, yet artistic license
was clearly permitted to the extent that details could be handled differently
from scene to scene. Thus, one soldier in this relief wields his axe with one hand
implausibly twisted, whereas his spear is more correctly held in a closed fist.

To avoid serial repetition, so common in traditional Egyptian multiple
figure representations, the Amarna artisan spaced his figures more generously
than before and has varied their positions. This scene, probably part of a narra-
tive over a large expanse of wall, is unencumbered by the usual verbose texts
of earlier periods, and we should not be surprised to find that the figures were
not firmly fixed to ground lines and were possibly surrounded by landscape
details. Although the relief is sunk, there is some overlapping of forms and a
consequent interplay of raised and sunk relief.

Further reading Aldred, *Akhenaten/Nefertiti*, cat. no. 39 where Memphis is proposed as a
provenance due to related scenes there where the king's bodyguards run along with the
royal chariot; G. Roeder, *Amarna-Reliefs aus Hermopolis* (Hildesheim, 1969).

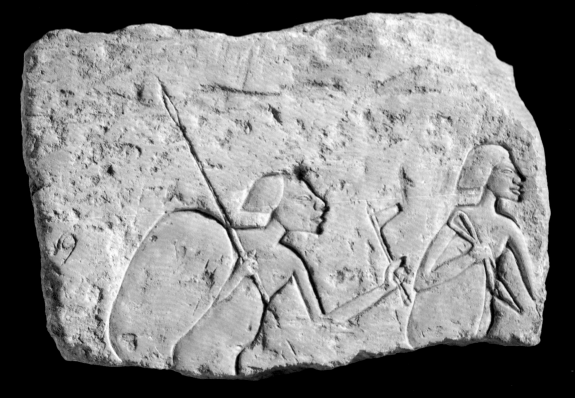

HEAD OF HATHOR
FROM A JAR

—

E.G.A.6185.1943
Nile silt with pigment. Height 14.9 cm,
width 15.5 cm. Said to come from el-Amarna.
New Kingdom, Dynasty XVIII, Amarna Period,
reign of Akhenaten, 1353–1337 B.C.
Given by R. G. Gayer-Anderson.

Hathor was to the Egyptian a mother goddess whose name literally means 'House of Horus'. The god Horus, incarnate as the king of Egypt, was nurtured by her, yet she was also called the daughter of Re. Hathor was the celestial cow who wore the sundisk and bovine horns as her crown and who was also considered the mistress of joy, dance, music and love. She was closely associated with and later assimilated to Isis, wife of Osiris. She is also distinguished as having absorbed the deities and cardinal orientations of Nekhbet (South), Wadjit (North), Bastet (east) and Neith (west). For this reason, she is frequently shown on the four faces of columns.

This painted sherd is presumably one of four moulded decorations applied to the neck of a large pottery vessel. The goddess is shown with a polygonal human face, bovine ears with radiating lines and a long female coiffure which is bound in lappets. The extremely elongated eyes with even longer cosmetic stripes are due to the sideways stretch of the face. The goddess wears a jewel at her forehead and a three tiered collar at her neck. Her face is painted pale reddish brown, the details are in red and black and the wig in light blue. These are the colours characteristic of painted pottery dating to the time of Amenhotep III and his son and successor, the heretic king Akhenaten.

The four-fold Hathor appliqués from vessels dating from the reign of Amenhotep III derive from his palace at Thebes. If this sherd does come from the city of el-Amarna as reputed, it may indicate a trace of private traditional piety in the city where king Akhenaten had suppressed the representations of the orthodox pantheon of gods.

Further reading Bourriau, *Pottery*, cat. no. 55; P. Derchain, *Hathor Quadrifons* (Istanbul, 1972).

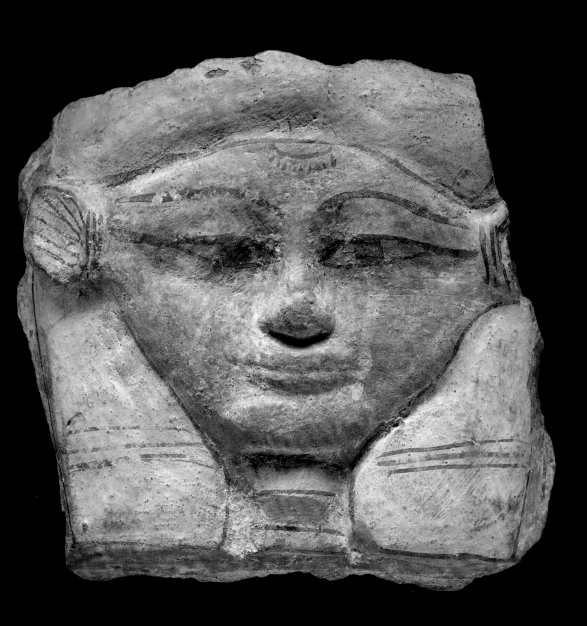

SHAWABTI OF SENNEDJEM

E.9.1887 Limestone with pigment.
Height 21.5 cm. Probably from Deir el Medina,
Tomb 1 of Sennedjem. New Kingdom, Dynasty XIX,
reign of Sethos I, 1294–1279 BC.

Shawabtis, also known as shabtis or ushabtis, were funerary mummiform figures surviving from the Middle Kingdom onwards. It was not until the New Kingdom that the pharaoh also included shawabtis among his tomb equipment. In a society that depended on the successful marshalling of its human resources for irrigating the land, even the dead were expected to perform their part in the Netherworld. Shawabtis were meant to irrigate and till the land on behalf of the deceased. From the New Kingdom onwards shawabtis were equipped with agricultural implements, and this shawabti of Sennedjem holds a broad bladed hoe against his right shoulder and a hoe with pointed blade against his left shoulder. A basket for seeds is depicted on his back, slung by a rope over his right shoulder.

By the late New Kingdom the ideal number of shawabtis in a tomb was 365, one for each day of the year as reckoned by the Egyptians. The shawabti ensemble was equipped with figures of overseers who ensured that the shawabtis performed their duties. The overseers were often distinguished by their elegant long skirts, whips and staffs.

Shawabtis were often mould made in faience so that great numbers could be produced. The shawabti of Sennedjem however is modelled in limestone, and all the details and the text are painstakingly hand carved and painted. Sennedjem was himself a workman in the Valley of the Kings during the reign of King Sethos I, and he therefore had the resources at his disposal to hew and equip a fine tomb for himself and his family.

The text invokes the shawabti as a servant, literally 'hearer of the call', to act on behalf of Sennedjem if required at any of the works which are done in the necropolis.

Further reading For the tomb of Sennedjem see PM, I: pt I, pp. 2–5. For another shabti of Sennedjem see Hayes, *Scepter*, II, fig. 272; Paris, Hotel Drouot Catalogue (16 November, 1973), A 39, B 40. For Sennedjem's genealogy; see M. L. Bierbrier, *The Late New Kingdom in Egypt* (c. 1300–664 BC.), (Warminster, 1975), pp. 30ff.; Schneider, *Shabtis*.

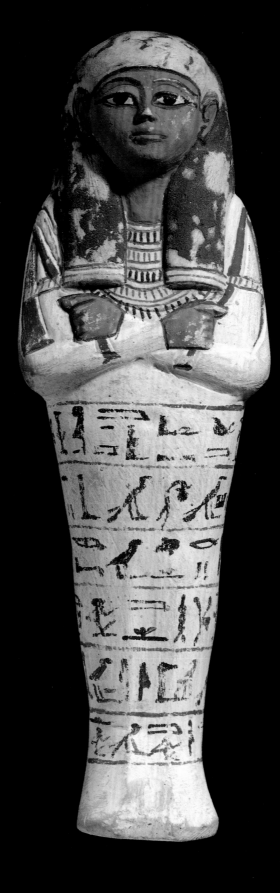

HEAD OF HATHOR

—

E.4.1905 Quartzite. Height 25 cm. Excavated at Serabit
el Khadim in Sinai peninsula, Temple of Hathor. New Kingdom,
Dynasty XIX, reign of Ramesses II, 1279–1213 BC.

This head of the goddess Hathor was excavated by Sir Flinders Petrie at the site of Serabit el-Khadim in Sinai, a place where turquoise was mined from the Middle Kingdom onwards. Hathor was recognised as 'Mistress of Turquoise', and a temple was built for her in Sinai, its approach dotted with caves fronted by enclosures and numerous stelae. It is thought that a peculiarly Semitic type of worship took place there, and that miners slept in the caves after propitiating Hathor, in order to dream oracular answers for mining success. In addition, animal sacrifices are thought to have taken place before Hathor's temple.

The goddess Hathor is represented with her crown of bovine horns and central sundisk. She wears a wig rather than the vulture head-dress and two uraei at her brow. Generally, in Egyptian pharaonic art, sculptures of gods, the royal family and private persons imitated the image of the king. Thus, our image of the deity is shown with the visage of Queen Nefertari, which was in turn modelled after her husband Ramesses II. The broad face with squared chin, blunt eyes with incised rims and cosmetic stripes and the small fleshy mouth are sculptural traits of the long reign and prolific artistic output of Ramesses II. The double uraeus, presumably referring to rule over both Upper and Lower Egypt, was worn in the late Dynasty XVIII by queens, by Tutankhamun and also by Nefertari, so that here we have almost a complete assimilation of the goddess Hathor with the queen.

Mining expeditions in the Middle and New Kingdoms involved hundreds of miners, labourers, temple builders and artisans, water and food carriers and knowledgeable desert Bedouin. Many royal and private benefactions to Hathor accompanied these dangerous expeditions and many sculptures and stelae were made at Sinai using local materials. Such was the case with sculpture, probably carved by artisans sent to work on the decoration of the temple of Hathor which was extended over several centuries. What has not been fully understood is what happened to the mined turquoise. Little turquoise appears in Middle Kingdom art, and almost none has survived from the New Kingdom.

Further reading W. M. Flinders Petrie, *Researches in Sinai* (London, 1906), p. 125, fig. 140; G. Pinch, *Votive Offerings to Hathor* (Warminster, 1994).

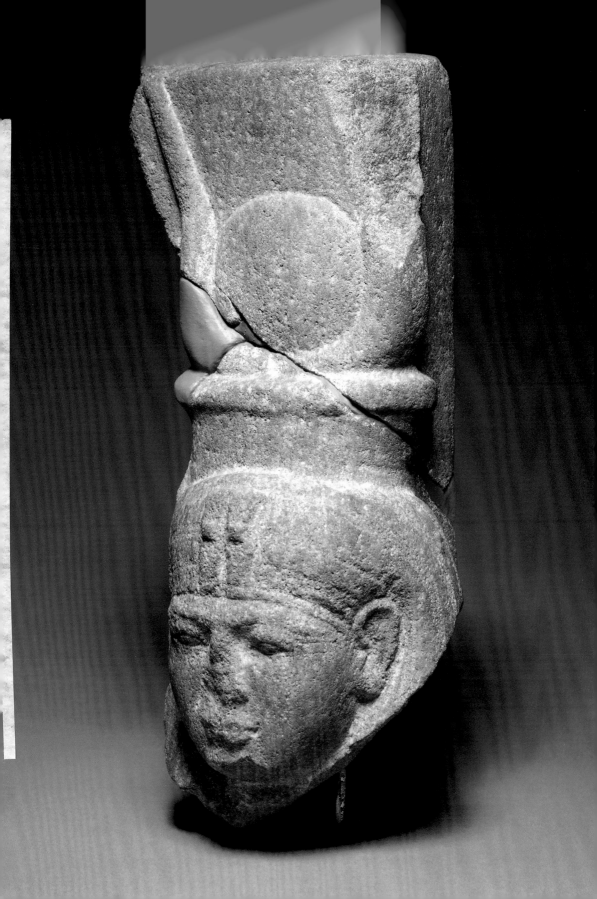

BLOCK STATUE

E.5.1968 Red Quartzite. Height 56.5 cm.
New Kingdom, Dynasty XIX, reign of Ramesses II,
1279–1213 BC. Formerly Ernst Brummer, W. R. Hearst and
Parrish–Watson Collections. Purchased through the Sir R. M. Greg
and Victoria and Albert Museum Grants in Aid Fund.

A familiar way of reposing in the Middle and Far East is to squat on one's haunches resting the arms on the knees, level with the shoulders. Although both men and women squat in this way, this type of statue was confined in Egypt from the Middle Kingdom to men only. The block statue type is a reduction of forms, since the limbs were meant to be understood as covered by the garment. One can say that this statue type is to sculpture what the pyramid is to architecture. The form was also less labour-intensive to produce. The block statue was of sturdy construction and not generally susceptible to breakage, a profound concern for the Egyptians. That is why the negative spaces between limbs were not removed from stone sculptures, and the head was supported at the neck by a back pillar. What was most appealing about the block statue type was that it provided the sculptor with several surfaces for the titles of the individual and other texts, surfaces not normally available on a striding or seated statue. The fact that the whole figure could be engaged to a back pillar allowed a further number of columns of text to be inscribed, and at the same time reduced the chance of the head being detached.

Although men of means chose to be represented in this position, kings were never shown as block statues. Unfortunately, the present figure was deliberately hacked at so that the texts break off before revealing his name. He was nevertheless an official close to the king, a royal 'Fan Bearer' and perhaps even the Viceroy of Nubia. He wears a wig typical of Dynasty XIX, plaited, crimped and twisted at the ends. His rounded face is reminiscent of the broad face of the goddess Hathor (no. 32), the eyes are equally blunt, though there was no attempt made here to suggest cosmetic rims or eye-brows by means of incision. The straight lips follow the expanse of the broad chin which is connected to the top of the block by a short beard. The arms, obscured by the garment, are folded across the knees and one hand is shown clasping a fan.

Further reading Hayes, *Scepter*, II, pp. 346ff. and fig. 219 for the distinctive coiffure; for the period and contemporary private sculptures, see Paris, Grand Palais, *Ramsès le Grand* (Paris, 1976).

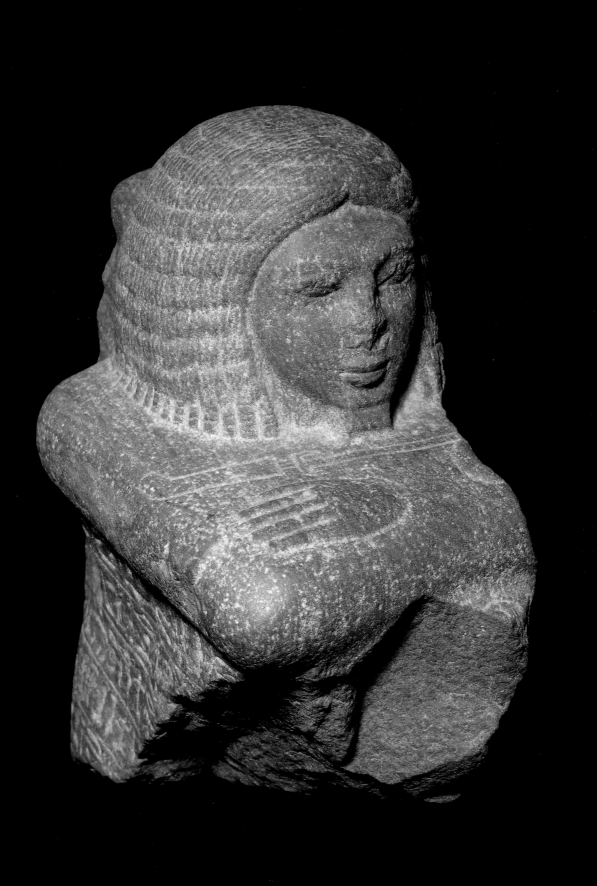

MODEL INK PALETTE

—

E.428.1982

Slate. Dimensions: 10.9 cm × 6.1 cm × 9 cm.
New Kingdom, Dynasty XIX, reign of Ramesses II,
1279–1213 BC. Given by the Wellcome Trustees.

The scribe's palette (see no. 20) was traditionally a narrow rectangle of wood with two circular depressions for blocks of red and black ink and a slot for reed pens. The present fragmentary palette was a non-functional ceremonial or funerary version in stone. The palette belonged to the vizier Rahotep who served king Ramesses II and whose tomb is found at Sidmant. On the top surface of the palette Rahotep is shown flanking the ink depression with arms raised in adoration. The ink depressions have been transformed into the shen-hieroglyph, essentially a protective knot with regenerative significance. The scene above shows the falcon-headed sun god Re-Harakhty (no. 43) on his transport – a boat – moving across the heavens. The baboon god Thoth, who was the patron of scribes and the reckoner of time, and who according to the myth of the origin of the royal uraeus led the angry eye of the sun back from Nubia, sits as a guide at the front of the sun bark. Several decorated ceremonial palettes suggest that some were dedicated in the cult of the Eye of the Sun.

On the other side, Rahotep makes offerings to deities in two scenes. At the top, he offers praise to the creator god and divine craftsman Ptah in his shrine, and to Maat, goddess of truth and righteousness. Both deities emphasized the Ordered World. Below, Rahotep offers a palette to Thoth, shown in his other guise as an ibis-headed deity. Between them is a repository table with the shen-hieroglyph once again. Unfortunately, only very little of the dedicatory inscription remains, leaving it unclear whether this was a votive offering at a temple or a funerary palette.

Further reading W. M. Petrie, *History of Egypt*, III (London, 1905), p. 100. For the tomb of Rahotep at Sidmant, no. 201 see: W. M. Flinders Petrie and G. Brunton, *Sedment*, II (1924), pp. 28–31, pls. 71–72, 74–76; Hayes, *Scepter*, II, pp. 274–275, fig. 168.

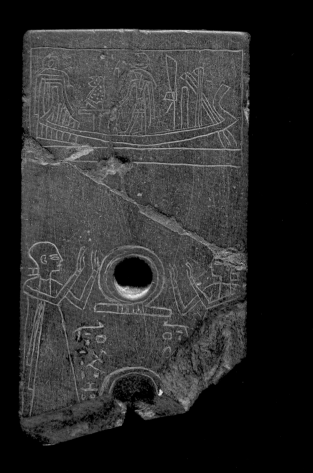
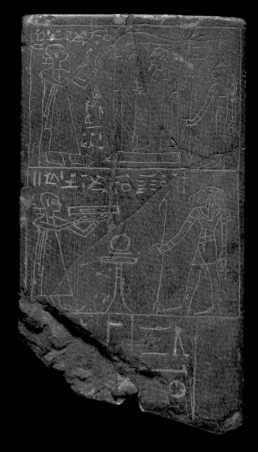

MONKEY BUSINESS

E.G.A.4292.1943; E.G.A.4293.1943
Two limestone ostraka. Dimensions: 11 cm × 9.75 cm;
8.5 cm × 13 cm. Late Dynasty XVIII – early Dynasty XIX,
1350–1250 BC. Given by R. G. Gayer-Anderson.

Just as we might doodle, so too the Egyptians drew free-style on pieces of stone and pot-sherds, and these we call ostraka (sing. ostrakon). Many unconventional subjects are preserved in such a way, including scenes from daily life, animal fables and erotica. Such drawings are extremely precious to us, since traditional representational conventions were often flouted in these genres.

From the earliest times, the Egyptians were enamoured of monkeys, and kept them as pets. Monkeys were imported from Nubia, beyond the southern border, and because of their playful behaviour they were associated with dance and music. Often the monkey was depicted in tomb decoration, usually seated under the mistress' chair. It was also shown as a worker carrying heavy sacks, and this role may account for its presence as a support on objects from the boudoir, such as kohl vessels, mirrors and the like.

Two pet monkeys wearing belts are shown on these limestone flakes. It is not clear whether specific stories are illustrated here or whether the artisan merely chose to represent a beloved pet. In one scene the monkey looks furtively over his shoulder as he scampers up a dôm palm tree to pick nuts. He is sketchily painted, his face is human and he wears a tiered male wig. His human aspect might refer to the mischievous behaviour of a child. In the other scene, a monkey drawn in considerably more detail is being chivvied along by a partially preserved figure wielding a long reed. The monkey looks back over his shoulder.

Further reading Brunner-Traut, *Sketches*, cat. nos. 22 and 23.

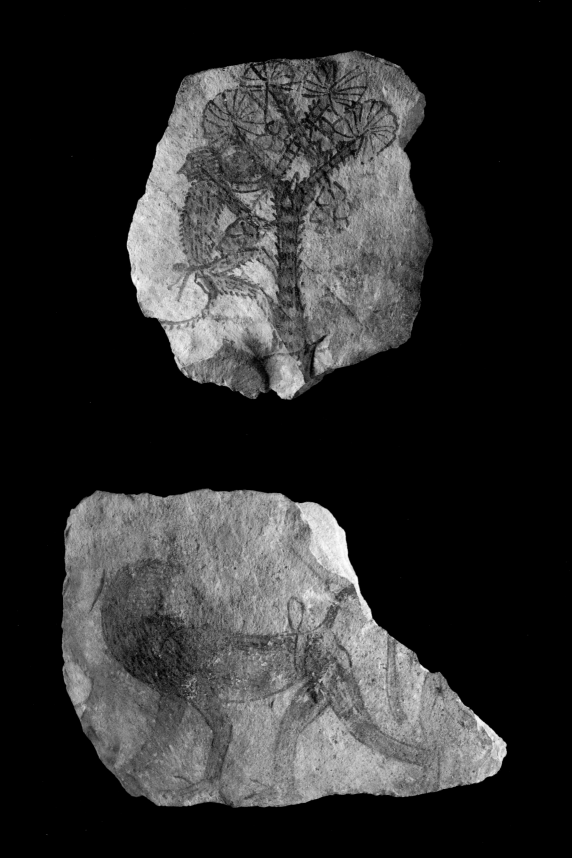

DRAWING OF
A MAN ON A POT-SHERD

—

E.106.1949
Terracotta. Height 13.9 cm, width 9.8 cm.
Late Dynasty XIX to Third Intermediate Period, 1295–1069 BC.
Bequeathed by R. G. Gayer-Anderson.

On this pot-sherd a field worker is depicted with buckets or baskets yoked over his far shoulder. Youth and beauty were Egyptian ideals, but unusually we are here confronted with an image of a human being marked by the rigours of daily life. The man is shown balding, with sparse dishevelled or windblown hair, hunched shoulders, a pronouncedly flaccid breast, thin limbs and with a walking stick in his free hand. He wears a cloth on his back as protection from the yoke, and a frayed or fringed wraparound kilt. The man is not depicted according to his various 'aspects', with the planes of the body parts rotated around a central axis. His shoulders are not frontal as we would normally expect, but approximate to a three-quarter view. Remarkably, the far leg is not advanced, but static. Nevertheless, the face is conventionally shown according to the ideal of beautiful youth.

Scenes of daily life were represented in the reliefs of el-Amarna (no. 29), whence a scene survives of a yoked water carrier climbing up from the shore of the Nile. Genre scenes in non-traditional style survived the Amarna Period for several generations, though here with stick-like limbs and stylized facial features.

Further reading Brunner-Traut, *Sketches*, cat. no. 15; Bourriau, *Pottery*, cat. no. 158; Peck and Ross, *Drawings*.

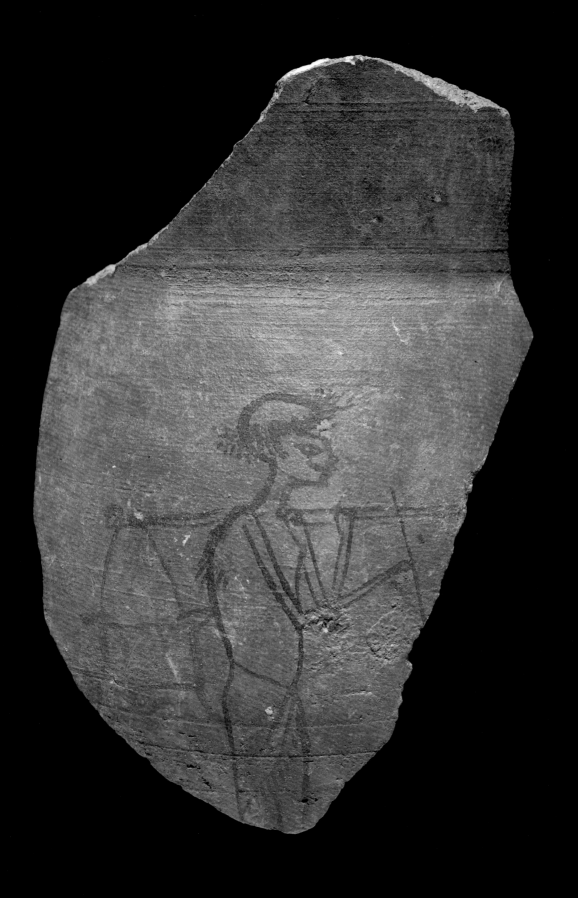

UNSHAVEN STONE MASON

—

E.G.A.4324a.1943
Limestone. Height 15 cm, width 13.5 cm.
New Kingdom, late Dynasty XIX – early Dynasty XX,
1200–1153 BC. Given by R. G. Gayer-Anderson.

Although so much Egyptian art survives, more than in any other ancient culture, we know very little about the artisans, who did not sign their works and left very little record of their lives. We do have, at least, extensive remains of the congested settlement at Deir el-Medina where the stone masons, artisans and workers lived who made the richly decorated tombs at Thebes. The bald stone mason or sculptor illustrated on this ostrakon gripping the tools of his trade, the chisel and mallet, may come from this site.

A cheerful brawny man with a short wide neck, shown correctly in profile view, a rare occurrence in Egyptian art, is bent at his task. The stone mason's beard is stippled and his mouth is open. Possibly, he is meant to be singing, while at work. He is endowed with an overly large ear and bulbous nose with a prominent nostril. Despite the uncharacteristic subject and approach, the man's eye is elegantly drawn with a pencil-thin eye-brow, according to the Egyptian ideal of beauty (see also no. 36).

The ostrakon is decorated on the verso with a scene showing a kneeling figure before the snake goddess Meretseger with a line of dedicatory text below. The Egyptians worshipped the subject of their fears, and snakes were a considerable worry to the workmen who made and decorated the royal and private tombs of Western Thebes. It is not clear whether this drawing served as a practice model for a stele that was more permanently decorated in relief or whether this was the ultimate dedicated object which was subsequently irreverently decorated with the stone mason on the recto. In either case, we have a telescopic glimpse both of the humour and the seriousness of the Egyptian necropolis workers.

Further reading Brunner-Traut, Sketches, cat. nos. 14, 46 (verso); Peck and Ross, Drawings, cat. no. 82; J. Vandier d'Abbadie, Catalogue des Ostraca Figurés de Deir el-Médineh, Documents de Fouilles Publiés par les Membres de l'Institut Français d'Archéologie Orientale du Caire, II, 1–4 (Cairo 1936–1959), nos. 2655–2658, 3011 ff.

JEWELLERY

E.45.1955 Gold wedjat-eye. Given by Sir W. P. Elderton. E.G.A. 145.1947 Electrum fish. Bequeathed by R. G. Gayer-Anderson. E.G.A.143.1947 Gold fish. Bequeathed by R. G. Gayer-Anderson. E.G.A.302a. 1947 Electrum shell. Bequeathed by R.G. Gayer-Anderson. E.12.1940 Gold amuletic decree case of Sak. Height 5.6 cm. Given by D.H.T. Hanbury. E.618.1954 Gold ring of Harkhebi. Bequeathed by Sir Robert Greg. E.35.1955 Gold ibis. Given by Sir W. P. Elderton. E.G.A.30.1947 Gold ring with sistrum and lotus. Bequeathed by R.G. Gayer-Anderson. E.65.1955 Gold wedjat-eye bead. Given by Sir W.P. Elderton. E.616.1954 Gold and glazed steatite scarab ring. Given by Sir Robert Greg. First Intermediate Period – Late Period, 2000–fourth century BC.

Egyptology is often associated with treasure, encouraged by the images of Tutankhamun's tomb. However gold was and is reusable and one can marvel at the objects in precious metal which have escaped millennia of thieves.

The oyster shell from the Red Sea was an amulet for women and a military insignia. The Tilapia amulet represented the female fish that swallow milt from the male and release the spawn, recalling the birth of the sun god Re as a fish from the mouth of the crocodile. The wedjat-eye is a human eye with the markings of a falcon's head. According to myth, Seth tore the eye of Horus to pieces, but it was restored by the god Thoth. The eye of Horus was believed to ward off the evil eye and every well-prepared mummy was equipped with one or more. Here we have one of hammered sheet and a pierced work bead with the eye reduplicated. The ibis amulet was sacred to the god Thoth who also appeared as a baboon. The tubular gold amuletic case once held the oracular decree of the god Khonsu, probably written on papyrus. It was worn as an amulet by a man named Sak who visited the oracle at Thebes, in Dynasty XXII.

A range of construction techniques is demonstrated by the rings: the earliest with oblong hammered bezel shows the chased image of the bovine Hathor head sistrum and lotus blossom; the rectangular seal ring, made of a gold plate soldered to a rod hoop; the massive scarab ring (for their significance see no. 21), here turned so that we see the underside of the scarab, is made of a thick rod of gold with a pivoting bezel held by a long wire wrapped around the hoop.

Further reading C. Aldred, *Jewels of the Pharaohs* (London, 1971); A. Wilkinson, *Ancient Egyptian Jewellery* (London, 1971); J. M. Ogden, *Interpreting the Past: Ancient Jewellery* (London, 1992); for the Tilapia fish see Herodotus, II, 93; for the amulet case see J. D. Ray in JEA, 58 (1972), 251–253. Two decree cases with the same name are in the Louvre.

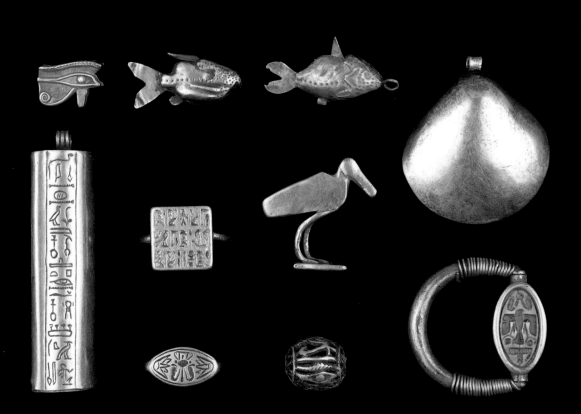

COFFIN LID OF RAMESSES III

—

E.1.1823 Red granite. Height 2.9 m, width 1.53 m, depth 83 cm.
From the Valley of the Kings, Tomb 11. New Kingdom, Dynasty XX,
reign of Ramesses III, 1184–1153 BC. Given by G. B. Belzoni.

In the early nineteenth century, the great circus strongman Giovanni Belzoni, who acted as an agent for the British Consul-General, Henry Salt, moved this imposing coffin lid of Ramesses III and many other large monuments to Alexandria, from where they were shipped to the new museums in Europe. Belzoni's legendary strength and engineering acumen enabled him to move objects where French and Italian agents had failed. Owing to its size and weight it was a difficult object to display satisfactorily until engineers, together with concrete specialists, were able to stand the monument upright.

The seven-ton sarcophagus lid is appropriately cartouche-shaped for its royal occupant. The sarcophagus itself, with texts concerned with the passage of the king to the Afterlife on both the exterior and interior, is preserved in the Louvre. Ramesses III is shown mummiform on the lid, and with the flail and crook attributes of the god Sokar-Osiris, gate keeper of the city of the dead. A festival of Sokar-Osiris was celebrated at the great temple of Ramesses III at Medinet Habu. The king's head-dress is composed of the ostrich feathers, sun-disk and ram's horns. Ramesses wears a long wig, uraeus and a long plaited divine beard which was once curled. The two mourning sister goddesses, Nephthys and Isis, stand on the hieroglyph for the word 'gold' and protectively embrace the deceased king. Between them and the king are pairs of snakes, two of which are female-headed and who reinforce the protection of the king. There were over forty varieties of serpents in ancient Egypt which were both feared and positively revered as apotropaic mediums and eternal beings because they shed their skins and regenerated themselves.

Unfortunately, ancient robbers plundered the tomb of Ramesses III by pounding at the corner of his lid to reach the jewel encrusted pharaoh whose robbed body was later moved by priests to another tomb. Recently, an archaeologist cleaning the silted-up tomb of Ramesses III, has found several of the lost fragments from this lid.

Further reading S. Birch, Remarks upon the Cover of the Granite Sarcophagus of Rameses III in the Fitzwilliam Museum (Cambridge, 1876); E. A. W. Budge, A Catalogue of the Egyptian Collection in the Fitzwilliam Museum Cambridge (Cambridge, 1893), cat. no. 1; Myśliwiec, Le Portrait, pp. 124ff., fig. 288.

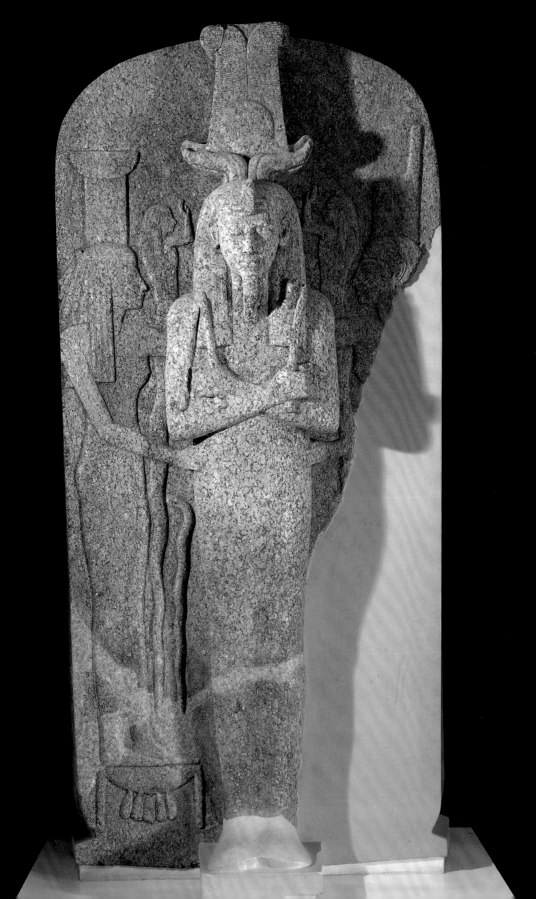

PAPYRUS OF INPEHUFNAKHT

—

E.92.1904 Papyrus with decoration. Length 176.5 cm, width 37.9 cm.
Third Intermediate Period, Dynasty XXI, 1070–945 BC. Probably from a tomb
of a priest of Amun at Deir el-Bahri. Bequeathed by Frank McClean.

The Book of the Dead was a vertically written text with interspersed vignettes which illustrated ever increasing chapters derived from such sources as coffin texts, pyramid texts, Judgement in the Afterlife and sun hymns. Generally, each Book of the Dead papyrus contained an individual selection of chapters, the scholarly sequential ordering of which is derived from a fairly long Ptolemaic text, though the order was never fixed in antiquity. The Book of the Dead was meant as a navigational guide through the Afterlife and as a substitute for elaborate tomb decoration.

Inpehufnakht, like his father Asakhet was a member of the staff of the temple of Amun-Re, and chief of the sailors of the god's bark. In a detail from this long Book of the Dead papyrus the deceased appears with his arms raised in praise. He wears a fillet and perfume cone on his head, and a fine white diaphanous garment under which his body is coloured pink.

Inpehufnakht faces a shrine with open door and recites what appears to be a garbled version of chapter 125 of the Book of the Dead, where he states that

> I did no evil in that land in the broad hall of the two truths, because I know the names of these gods who exist in it...I have not blocked the god in his procession. I am pure... My purity is the purity of the phoenix...

On the rest of the papyrus, the forty-two assessors and the Negative Confession appear, followed by the Book of Becoming a Swallow and the Chapter of Entering the Region of Sand. At the opposite end of the papyrus the Bark of Re is accompanied by a hymn for the setting sun which is about to be received in the arms of the sky goddess. The papyrus like other examples of the period is unique in its combination of motifs and scenes. This Book of the Dead combines solar motifs with vignette illustrations from chapters 126 and 110, and again scenes of adoration of the forms of Re with that of the judges from chapter 125.

Further reading E. Hornung in *Aegyptiaca Helvetica*, 3 (1976), 101 n. 25, 102 n. 35, 37, 103 n. 39, 41; F. W. Green in O. M. Dalton, *The Fitzwilliam McClean Bequest* (Cambridge, 1912), pp. 124–125; A. Niwiński, *Studies on the Illustrated Theban Funerary Papyri of the 11th and 10th centuries BC*, Orbis Biblicus et Orientalis, 86 (Freiburg and Göttingen, 1989), p. 103, fig. 11, p. 139, figs. 28, 29. For the coffin of an Inpehufnakht in Leiden, see PM, I, pt 2 (2nd edn) p. 638.

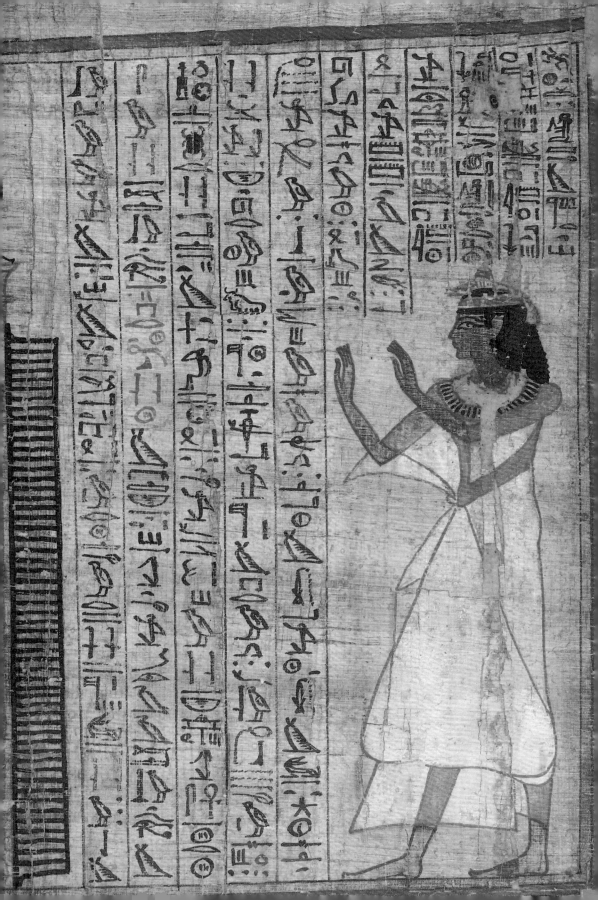

THE SYCAMORE GODDESS

—

E.1.1822 Plastered and painted wood. Length 1.90 m, width 60 cm, depth 49 cm.
Third Intermediate Period, Dynasty XXI, reign of Pinudjem II, 990–969 BC.
Given by B. Hanbury and G. Waddington.

There is a profound change in coffin decoration in the Third Intermediate Period when the tombs were no longer decorated, and so the wall paintings and funerary texts were transferred to the papyri (no. 40) and coffins. The heightened role of the Amun priesthood in Dynasty XXI (1070–945 BC), coincided with changes in burial arrangements and equipment, and iconographic compositions. The evolution continued so that there are distinct differences in media, style and iconographic content between Dynasties XXI and XXII (no. 42).

The Fitzwilliam Museum is fortunate to count among its earliest acquisitions the coffins and a wood anthropoid cover from the mummy of the man Nespawershefi. These were the gifts of two university college Fellows who travelled to Egypt in 1820 in the wake of Napoleon's army, accompanying the army of Muhammad Ali in its conquest of the Sudan. Napoleon had stimulated European awareness of Egypt as a result of his Egyptian expedition, which included scientists and architects who systematically recorded the flora, fauna and all standing ancient monuments.

The scene from the exterior of the inner coffin shows Nespawershefi kneeling in his finely pleated linen garments as he makes an offering to the sycamore tree goddess, Nut. The Ba or bird-like aspect of Nespawershefi's soul is shown in the shade of the sycamore tree, drinking from the liquid which the goddess pours. The sycamore tree was planted in gardens and near tombs where the goddess Nut was believed to comfort the dead and their Bas.

Sloped bands of red with rows of dots suggest the hills and sand of this desert. The tomb is designated by a doorway with a colourful cornice surmounted by a small pyramid, typical of the period. The yellow ground of this and other contemporary coffins was intended to evoke gilded royal coffins.

Nespawershefi was chief of all the scribes of the Temple of Amun at Karnak, probably during the reign of King Pinudjem II (990–969 BC). Unfortunately, the whereabouts of his tomb, presumably in western Thebes, is unknown.

Further reading E. A. W. Budge, *A Catalogue of the Egyptian Collection in the Fitzwilliam Museum Cambridge* (Cambridge, 1893), pp. 7–58, esp. pp. 44–45; PM, I (2nd edn) pt 2, p. 824; A. Niwiński, *21st Dynasty Coffins from Thebes: Chronological and Typological Studies, Theben, 5* (Mainz, 1988), cat. no. 156.

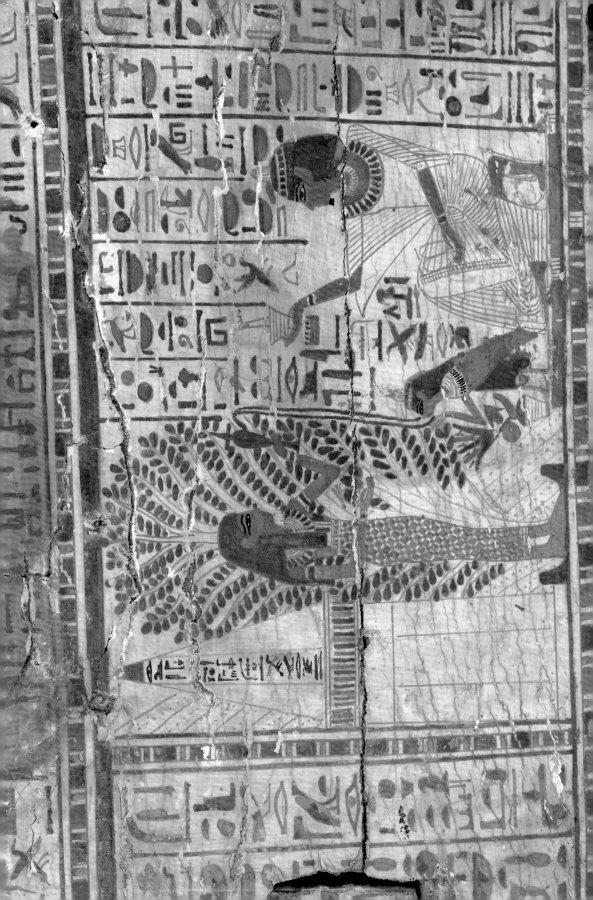

COFFIN OF NEKHTEFMUT

—

E.64.1896 Cartonnage with relief decoration, white ground and polychrome,
gilded face, glass and faience inlays in eyes and beard. Height 1.775 m, width 44 cm,
depth 33 cm. Third Intermediate Period, Dynasty XXII, reign of Osorkon I, 924–889 BC.
From the Ramesseum, Thebes. Given by the Egyptian Research Account.

Nekhtefmut was the Fourth Prophet of Amun. His anthropoid coffin, unlike the
wood coffin of Nespawershefi (no. 41) was made of cartonnage, linen impreg-
nated with resin, and the decoration is on a white, and not a yellow ground.
The mummy, removed by the nineteenth-century excavators by cutting along
the back and sawing off the stitched wooden foot panel, was perhaps not as
long as the coffin but reached only to the shoulders of the cartonnage case.

The cartonnage is decorated with a long wig and protective scarab at the
crown of the head. The face is gilded, the eyes and beard are inlaid with shell and
blue faience and glass. The sun barks of the dawn and dusk journeys are shown
on his right and left shoulders. Nekhtefmut wears on his chest an amulet of Maat,
goddess of righteousness. Below the god Horus pours a libation to his deceased
father Osiris, King of the Afterlife. Opposite, over the deceased's left hip the god
Thoth in the form of an ibis is before the fetish of the god Amun. Protective sister
goddesses of mourning, Isis and Nephthys (no. 39) appear as winged females and as
falcons. Texts and images from chapter 125 of the Book of the Dead cover the sides.

The intact excavated tomb of Nekhtefmut was found to be a makeshift
one at the bottom of a well some fifteen feet below the surface at the site of the
Ramesseum, funerary temple of King Ramesses II (1279–1213 BC). The well-
opening was so narrow that the three wooden coffins of Nekhtefmut could only
have been assembled *in situ*. Between mummy and cartonnage were: leather
braces and a leather *menat*-counterweight with the stamped cartouche of the
reigning king, beads, amulets, heart scarab, electrum winged scarab, flower
bouquets, a papyrus inscribed with sections of chapters 11, 142 and 17 (verso) of
the Book of the Dead and a linen fragment with the words 'Year 33' and 'Year 3'
perhaps referring to the regnal years of Osorkon I and his co-regent Shoshenq II
(891 BC). Just beyond his coffin were found Nekhtefmut's wood shawabti box
with eighty-nine shawabtis within. Nearby were the wooden statuettes repre-
senting the Four Sons of Horus. Only three decorated blocks from the super-
structure of Nekhtefmut's funerary chapel were found in debris at ground level.

Further reading J. E. Quibell, The Ramesseum (London, 1898), pp. 10–11, 16, 18, pls. XVI,
XVII, XXII; PM, I, pt 2 (2nd edn), pp. 679–80; LÄ, V, 434–468.

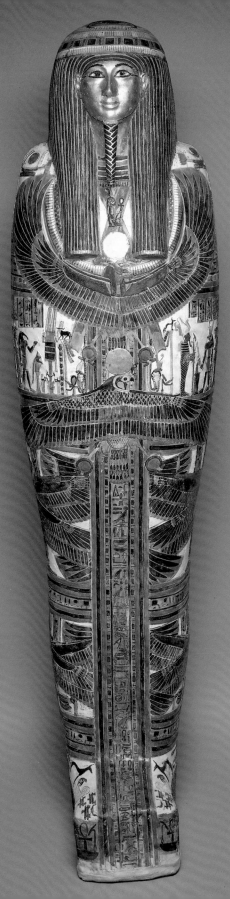

THE CHANTRESS OF AMUN, TENTESAMUN

—

E.264.1932
Painted wood. Height 24 cm, width 19 cm.
Third Intermediate Period, Dynasty XXII, 945–715 BC.
From Thebes. Bequeathed by E. Towry-Whyte.

This modest votive monument belonged to a woman who probably played a minor part in the daily rituals within the great complex of temples and shrines at Thebes, modern Luxor, in Upper Egypt. She sang for the hawk-headed Amun-Re, the sun god, manifest in the rising sun, the 'sun upon the horizon', Re-Harakhty. Her relationship with him was close throughout her life; her duties as chantress took her into his temples regularly; her name means 'she who belongs to Amun', and in facing death she turned to him to ensure her immortality.

On her stele she faces her god, offering worship. She presents an ideal of female beauty, but it is a different one from that of Intkaes who lived over 1,500 years earlier (see no. 6). Tentesamun is small and plump, not slender, and instead of a simple tunic, she wears a transparent, pleated linen gown with a hem fringe and a rectangular shawl. The folds of the dress are indicated by yellow stripes and the decorative edging is shown in black. She wears a long, heavy wig reaching almost to her waist, and on her head is a conical cake of perfumed ointment garlanded with flowers. To be sweet-smelling was an important attribute of beauty.

Before Tentesamun is the familiar repository table with offerings, shown in plan, so that the onlooker can see both the table and the foodstuffs on it – a traditional device of the Egyptian artist. The round flat loaves, are kept fresh under green palm leaves. An ewer and a jar for water offerings are shown above, and below are two pottery storage jars, sealed with mud, and standing on pot stands. J.B.

Further reading J. -P. Corteggiani, *The Egypt of the Pharaohs at the Cairo Museum*, (Eng. edn, London, 1987), cat. no. 91.

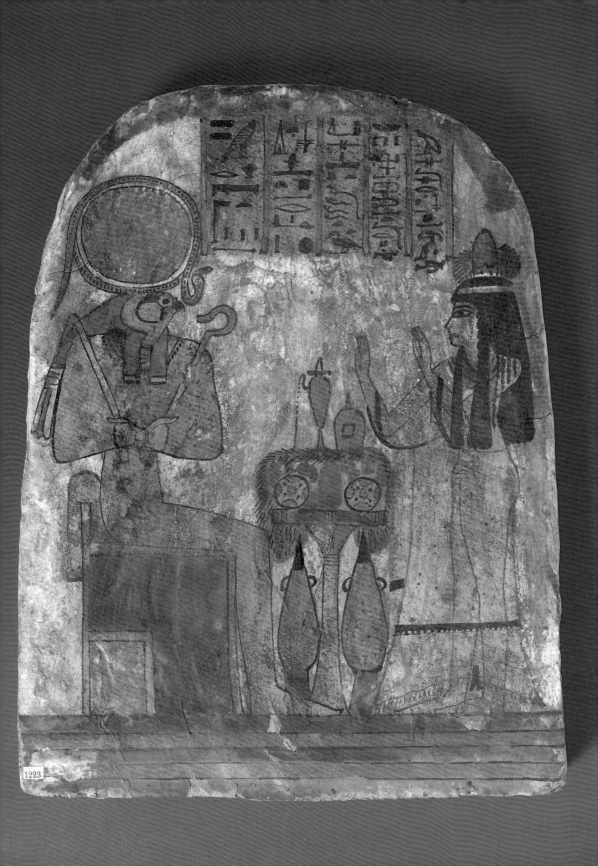

TORSO OF KING SHOSHENQ

—

E.6.1969 Frit. Height 15 cm. Third Intermediate Period, Dynasty XXII,
Shoshenq V (?), Aakheper Re 767–730 B.C. From Saqqara, Sacred Animal
Necropolis, debris in sector I. Given by the Egypt Exploration Society.

Ever since the Old Kingdom the Egyptian male was sculpted as though striding,
with left leg advanced. This pose demonstrates the preferred rightward orien-
tation which also enabled the figure to be translated into two dimensions –
according to Egyptian thought an image was a hieroglyph for the real thing
and the hieroglyph was translatable into the real thing. In two dimensions the
advanced left leg could not be obscured by the right leg. The arms were, as
here, usually modelled at the side of the body.

The pleated wraparound shendyt-kilt with central lappet was the royal male
garment until the Middle Kingdom when private men adopted it as well. The
back pillar is thought to have served standing figures in stone as a reinforcing
strut, and its absence on bronze figures lends support to this theory.
However, back pillars were not generally present on wooden figures liable to
break, but were included on stone seated (no. 20) and squatting block statues
(no. 33), though never kneeling ones (no. 52). The flat surface of the back pil-
lar enabled the artisan to retain the proportional grid as a guide while carving
the figure. Finally, the back pillar provided a much needed surface for the titles
and invocation of the votary or epithets of a king or deity.

This statuette is made of a compact, fine-grained siliceous material which,
in simple terms, is halfway between the more granular 'Egyptian blue' (no. 57)
and a true glass. The basic form was cast but the final details, and perhaps
much of the final form was hand worked by engraving and abrading. This
material is quite tough but here, even the excessively wide back pillar could
not protect the head from breakage, although, happily, the inscribed text did
protect the king from complete anonymity. Nevertheless, it is not certain
whether this is Shoshenq IV or V. The period in which both lived is a confus-
ing one; disintegration of unified rule occurred in Egypt due to royal relatives
establishing regional independent chiefdoms at a particularly sensitive time
when the Assyrians were threatening Egypt's commercial interests.

Further reading G. T. Martin, The Tomb of Ḥetepka and other Reliefs and Inscriptions from...
North Saqqâra 1964–1973 (London, 1979), cat. no. 155. Paris, Tanis: L'or des Pharaons (Paris,
1987); B. G. Trigger, B. J. Kemp, D. O'Connor and A. B. Lloyd, Ancient Egypt: A Social History
(Cambridge, 1983/repr. 1989), chapter 3.

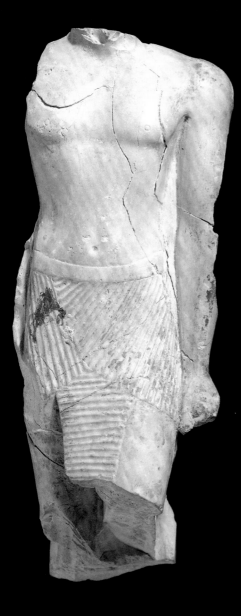

A STRIDING SPHINX

—

E.1.1992 Limestone with traces of plaster and pigment.
Dimensions: 27 cm × 26 cm × 3 cm. Third Intermediate Period,
1069–715 BC. Bought through the University Purchase Grant,
the American Friends of Cambridge University and the
Friends of the Fitzwilliam Museum.

This elegant raised relief probably comes from a temple wall. It celebrates the cult of the king with his image as a striding sphinx, carried within a portable wooden shrine and followed by a fan bearer. The king is adorned with a *nemes*-headcloth with double ostrich feathers, sundisk and royal cobras mounted on ram's horns. He wears a straight beard rather than the curled one of gods (see no. 47). These attributes establish that this is an image of the king and not of the sphinx deity Tutu. On festival days, the cult image was transported to other temples, usually in order to visit other deities or a consort deity. Since the normal mode of transport was a boat, the shrine was often represented on a bark carried by priests.

The goddess Nekhbet's protection is afforded by the vulture which hovers over the defaced cartouche of the king's name above his tail. Peculiarly, the feathers of her one wing are translated into the eye, an apotropaic iconographic symbol.

Traditionally the sphinx, metaphor for the king, was shown recumbent, or occasionally upright, trampling underfoot the foreign foe. Here however, we have possibly a unique image of the striding sphinx carried in a shrine. Under the sphinx is the motif of the Lower Egyptian papyrus plant between the back legs, and the Upper Egyptian lotus plant between the forelegs. The vertical hieroglyph under the belly of the sphinx is the heart and windpipe which signify the verb 'to unite' (*sema*) for the king who unites Upper and Lower Egypt under his dominion. The plants are elegantly attenuated and contracted in order to fill the empty spaces between the limbs of the sphinx.

Stylistically this fine relief is datable to the Third Intermediate Period (Dynasties XXII–XXIII, 945–715 BC) due to the emphatic wing of the nose and the pad of flesh at its corner. There are very few decorated monuments of this period. Originally the whole relief was gently plastered and painted in bright colour. Scenes in raised relief tended to be executed on the temple interiors, whereas scenes in sunk relief appeared on temple exteriors so that the sunlight could cast strong shadows.

Further reading K. Myśliwiec, *Royal Portraiture of the Dynasties XXI–XXX* (Mainz, 1988).

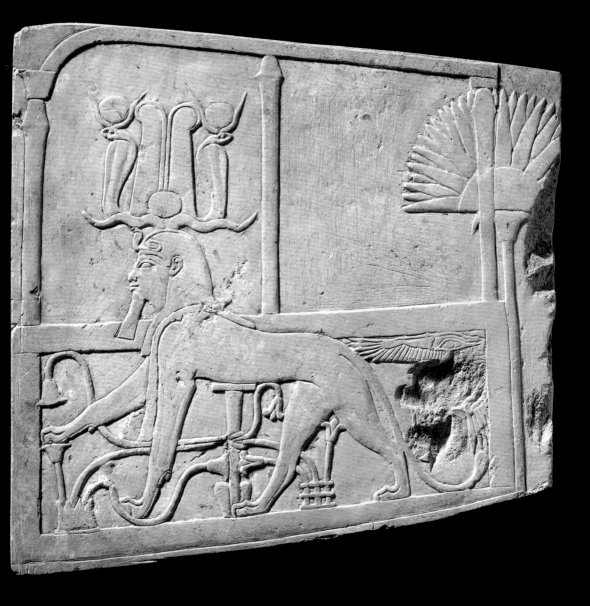

THE GOD MIN-AMUN

E.496.1954
Copper alloy with traces of gilding.
Height 23.3 cm. Third Intermediate Period,
1069–715 BC.

Amun, chief god of Thebes, first appears in the Egyptian pantheon, probably from about the time of Dynasty XI. He was usually shown as a man or as a ram or ram-headed man. According to the legend of the birth of the king, it was Amun who impregnated the queen consort with the future king. Amun shared the creation qualities and the fertility associations with the ram image of Min. Here the god Min-Amun stands tightly bound by his wrappings with right hand raised for his lost flail emblem and with his left hand gripping the lost erect phallus.

The figure is hollow cast with traces of gilding on the face and crown. Of the inlaid eyes and brows, only the white stone of the eyes remain. The irises are lacking. The face is strongly modelled with flat, narrow forehead, sharply sculpted nose, squared chin and slight smile around the mouth. The sweeping brows follow the contour of the crown. The chin strap was also once inlaid, the beard separately attached under the chin, and the jewellery and bindings were carefully incised, perhaps on the figure after casting. The feathers of the crown, the flail held in the raised arm and the phallus were separately attached. X-rays have revealed that a square-section peg for securing the figure to a base was passed through the soles of the feet and up the inside of the legs to the height of the knees. The presence of two rectangular 'mortises' along the side of the figure under the raised right arm and on both hips were probably by-products of the casting process, perhaps for holding the core in place. These were meant, no doubt, to be patched.

Analyses of the metal of the statuette have revealed that the figure was made from a copper-tin alloy with 4 or 5 per cent tin and a lead content of between 4 and 6 per cent, both certainly intentional additions. These are consistent with other bronze sculptures of the Third Intermediate Period.

Further reading E. Vassilika, 'Egyptian Bronze Sculpture Before the Late Period', *Chief of Seers: Egyptian Studies in Memory of Cyril Aldred* (London, forthcoming).

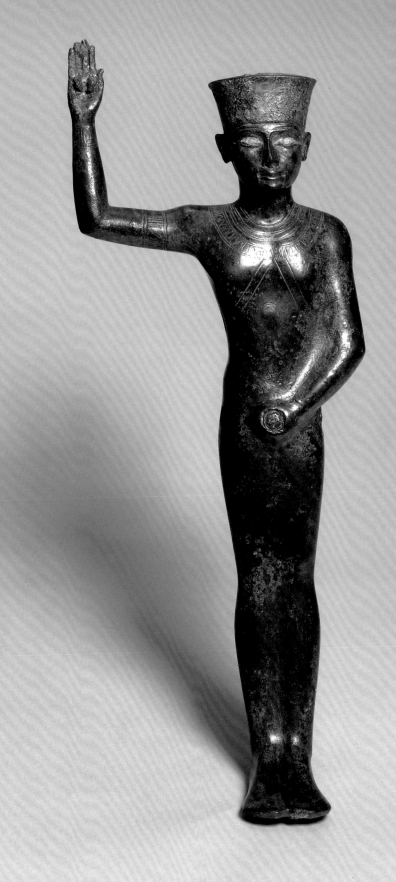

THE GOD PTAH

‒

E.160.1954
Copper alloy inlaid with gold. Height 13.9 cm.
Third Intermediate Period, 1069–715 BC.
Bequeathed by Sir Robert Greg.

The god Ptah was the craftsman whose cult was centred in the great city of Memphis. In the late New Kingdom it was believed that creation occurred through the word of Ptah. He was associated with Sakhmet and Nefertem in a divine triad, and also with the Underworld deities Sokar and Osiris. A New Kingdom hymn ranks Amun, Re and Ptah together and as having no equals. In the Late Period Ptah was regarded as the father of the Apis bull and of the deified Imhotep, architect of the step pyramid at Saqqara, later deified. Ptah was one of the few anthropomorphic male deities who wore a straight 'royal' beard and not the usual divine curled one. It has even been suggested that Ptah's straight beard was adopted by the king. The god's close-fitting cap was worn by smiths and craftsmen, an appropriate attribute for the mentor of craftsmen.

In this fine bronze, Ptah's eyes and broad collar are decorated with different coloured metals of gold and dark bronze. The deity stands enveloped in his mummy wrappings, which leave his head and hands exposed. He wears his characteristic cap and straight beard, and grips a notched *was*-sceptre against his body.

This statuette was hand-worked after casting, when the gold broad collar was inlaid into the bronze. The difference in colour between the gold inlays and the copper tin alloy of the figure is due to patination over time. Originally there would not have been such a contrast unless the bronze was deliberately darkened. Such darkening treatment was certainly carried out on some inlaid bronzes of the period, but cannot be proved in this instance. The style and surface decoration and the technique date this bronze to the Third Intermediate Period, in the first half of the first millennium BC, when although centralised rule broke down, curiously metalwork technology was in the ascendance.

Further reading G. Roeder, *Ägyptische Bronzefiguren, Staatliche Museen zu Berlin, Mitteilungen aus der Ägyptischen Sammlung*, VI (Berlin, 1956).

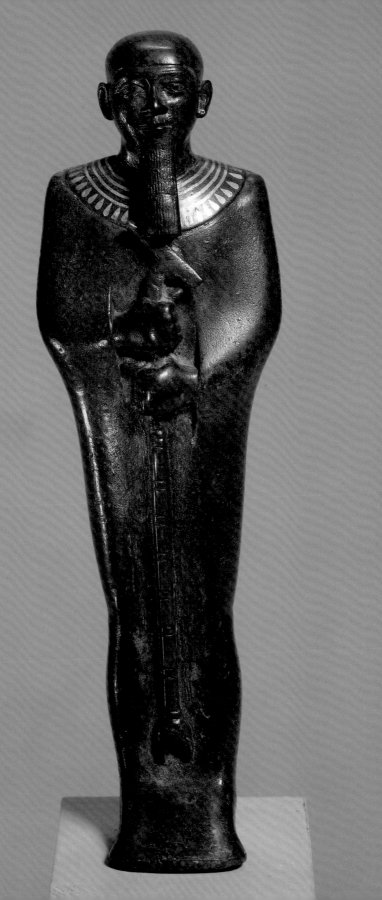

RELIEF OF THE GOD AMUN

—

E.7.1969 *Copper alloy. Height 17.9 cm, width 12.75 cm.*
From Saqqara, Sacred Animal Necropolis. Late Period, Dynasty XXV,
780–656 BC. *Given by the Egypt Exploration Society.*

The Kushites, who lived in Nubia beyond the southern borders of Egypt, were Egyptianized during the New Kingdom and were also introduced to the worship of the Egyptian god Amun. When the Kushites conquered their former Egyptian lords in the seventh century BC, their purpose was to reassert the pre-eminence of the god Amun.

In this relief of the period we see Amun with the characteristic traits of the Kushite kings. One notes the stocky proportions compared with the elegant attenuated male figures of earlier periods (nos. 40, 41, 43) and the forceful modelling of the face with an emphatic wing of the nose carved deeply into the face, the so-called Kushite fold. The deity has absorbed Nubian features.

Amun wears his characteristic box-like crown with streamer and a divine curled beard (no. 45) with chin strap. The deity is dressed in the wraparound *shendyt*-kilt (no. 44) with bovine or leonine tail which was regularly worn by gods and kings. His identity as a god is completed by the *was*-sceptre in his left and the *ankh*-sign in his right hand.

The broad collar around the neck and the armlets and bracelets were doubtless inlaid in more precious materials such as silver or gold. Additional details such as the lost feathers of Amun's crown and his throne were probably overlaid in other materials. The ancient Egyptians were fond of combining organic and non-organic, precious and semi-precious media for colourful surface effects. The entire plaque was also probably set with others onto a backing, perhaps wood, to form a context or narrative. We might expect another plaque of the king making an offering to the god Amun, and possibly the divine consort Mut behind the god. Unfortunately, only the bronze plaque has survived and we are left to supplement fragments and their inlays in our imagination. The extraordinary modelling of the legs with vertical shallow grooves of the musculature suggests that detail would not have been lacking in the precious metal inlays.

Further reading W. B. Emery, 'Preliminary Report on the Excavations at North Saqqâra 1966–7', JEA, 53 (1967), pl. 26:4; E. R. Russmann, *The Representation of the King in the XXVth Dynasty, Monographies Reine Élisabeth*, 3 (Brussels and Brooklyn, 1974).

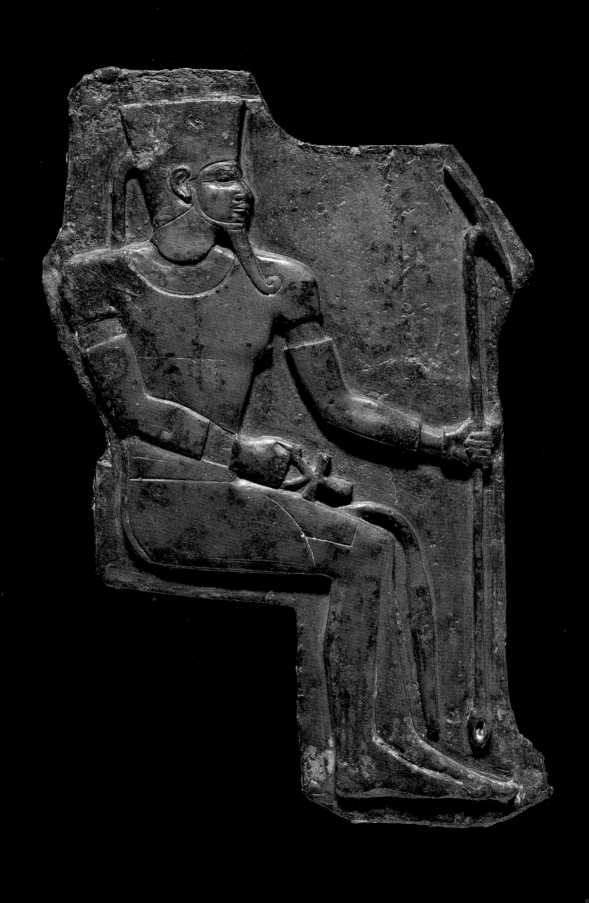

A DIVINE CONSORT

—

E.G.A.4542.1943 Sandstone.
Height 52 cm, width 35.5 cm, depth 4.5 cm.
Late Period, Dynasty XXV, 780–656 BC.
Given by R. G. Gayer-Anderson.

In order to help legitimize the Kushite rule (no. 48) a princess was 'married' to the god Amun. Thus Kushite conquest was divinely validated and the marriage of the princesses to the Theban god Amun was ritualised. The 'divine consorts', also called 'divine adoratresses', eventually became quite powerful themselves.

Before us is an elaborately coiffed and decorated divine consort in sunk relief. Her divinity is emphasized by the vulture head-dress of goddesses and the feathered crown of Amun which she wears over her finely plaited long hair. She is bejewelled with a beaded choker and broad collar. Although her earlobe is pierced she does not wear an earring. Peculiarly, the knotted halter strap and the broad collar are not depicted on her left shoulder. Once again the stylistic features such as the bold modelling of the face with emphatic wing of the nose or so-called Kushite fold (no. 48), and overall smaller head, especially evident from the compressed lower area of the face (compare no. 19), are characteristic of Nubian art.

Although fragmentary, we know that the divine consort was embraced by the god Amun, because one hand grips her near arm and another is behind her back. Such scenes are known from walls of chapels dedicated to divine consorts at Thebes. It is probable that this relief comes from one such monument.

Further reading LÄ, II, 797–801; J. Leclant, *Recherches sur les Monuments Thébains de la XXVe Dynastie dite Ethiopienne* (Cairo, 1965).

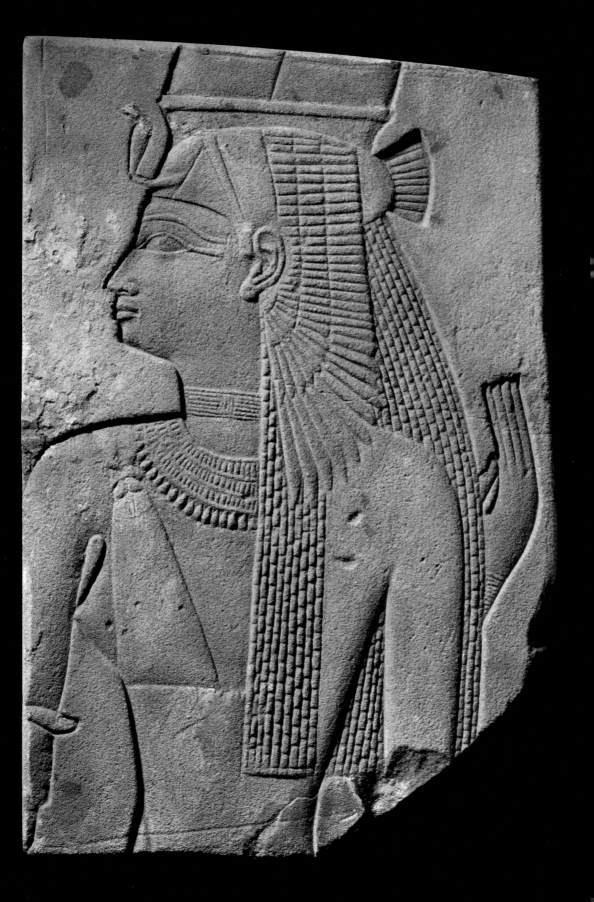

SHAWABTI OF HORKHEB

—

E.335.1954 Faience. Height 15.75 cm.
Late Period, early Dynasty XXVI, 715–610 BC.
Bequeathed by Sir Robert Greg.

Horkheb was the son of Khamkhons and his wife Nefer-Neith; he probably lived in the late eighth and early seventh century BC, about the time when a native pharaoh was reinstalled with the aid of the Assyrians and Greek mercenaries in a rebuff to the Kushites (nos. 48, 49). Horkheb – a statue inscribed with his titles survives in Vienna – was a courtier of the king and his father had been responsible for the king's funerary statues.

The fine faience shawabti of Horkheb is fully enveloped in mummy wrappings apart from his hands which wield hoes and a seed bag for his agricultural and other duties in the Afterlife (see no. 31). The trapezoidally shaped seed bag is held in place over his left shoulder by a rope. This fine shawabti exhibits stylistic characteristics which include the strong nasal wings recalling the 'Kushite fold' (nos. 48, 49), but also a non-Kushite elongated shaped face. Together such traits suggest a time of transition. The presence of the divine curled beard here signifies a closer association with the god Osiris of the Underworld than in earlier examples of shawabtis (no. 31). The figure was cast in a pale blue faience imitating turquoise that was favoured in Dynasty XXV, but the hard glassy surface of this type of faience which could be polished as a stone was favoured in Dynasty XXVI. The rectangular plinth forming the base, and back pillar are also first attested for shawabtis in Dynasty XXVI.

The broad back pillar provides space for three columns of text in addition to the two on the front of the figure. The text invokes:

> ...O these shawabtis, if someone calls out concerning me to do any of the works which are done in the necropolis to make the fields flourish, to irrigate the river-bank lands, to transport sand of the east and west by boat, if someone details me at any time, if someone calls out there and a man [i.e. Horkheb] is hindered at his duty, Here I am, you shall say, if someone calls my name.

Further reading For other examples of shawabtis of the same man (more than twenty are known) see Schneider, *Shabtis*, pp. 125–126; and Frankfurt am Main, *Ägyptische Bildwerke*, II: *Statuetten, Gefässe und Geräte* (Frankfurt, 1991), cat. no. 84; see also *Journal of Glass Studies*, II (1960) 34–35.

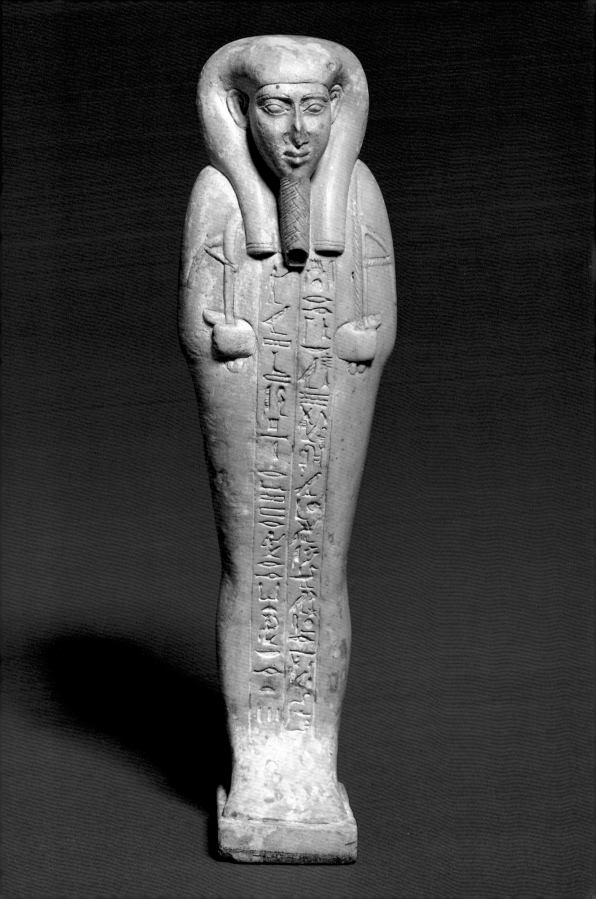

THE GODDESS NEITH

E.162.1954
Copper alloy. Height 23.25 cm.
Late Period, Dynasty XXVI, 715–525 BC.
Bequeathed by Sir Robert Greg.

In inscriptions Neith's name is written with her attribute, the hieroglyphic sign for two shooting bows bound together, and her name is reinforced by the crown she wears, since this too is phoneticised as 'Neith'. The essential role of the goddess was that of a hunter and warrior, who aided man against his enemy and protected the dead. As the mother of the crocodile god Sobek, she is related to the waters and the inundation. She was invoked early on, but by the Middle and New Kingdom her cult was in decline. With the establishment of the capital at Sais in Dynasty XXVI, the cult of Neith was firmly re-established, and her early primordial essence as mother of the sun, and as a genderless mother and father figure was re-emphasized.

In this fine bronze Neith as warrior goddess and personification of Lower Egypt strides like a man, originally gripping ankh- and was-sceptres, and wearing the Lower Egyptian or Red Crown. Her image was hollow cast as one with her crown, and the whole was attached to a plinth. The curled wire of the crown, now broken away, was probably a casting sprue which was bent into shape as its irregular surround suggests. Her manly sceptres were separately inserted. This superbly executed bronze shows the crown, the eye-brows, rims, cosmetic stripe, nipples, beaded broad collar, armlets, wristlets and anklets all carefully detailed.

The goddess is modelled with broad facial features, and a wide thin-lipped mouth, a short wide neck and wide squared shoulders. Her dress, defined as such only at the hem, reveals a developed bosom, a strong median contour and elongated navel. Her waist is low and her legs are thick. Due to the revival of Neith's cult in Dynasty XXVI most bronzes of the goddess are dated to that epoch.

Further reading For the goddess Neith see LÄ, IV, 392–94; for an almost identical example in Cairo see G. Daressy, Statues de Divinités, Catalogue Général des Antiquités Égyptiennes du Musée du Caire, no. 38.954.

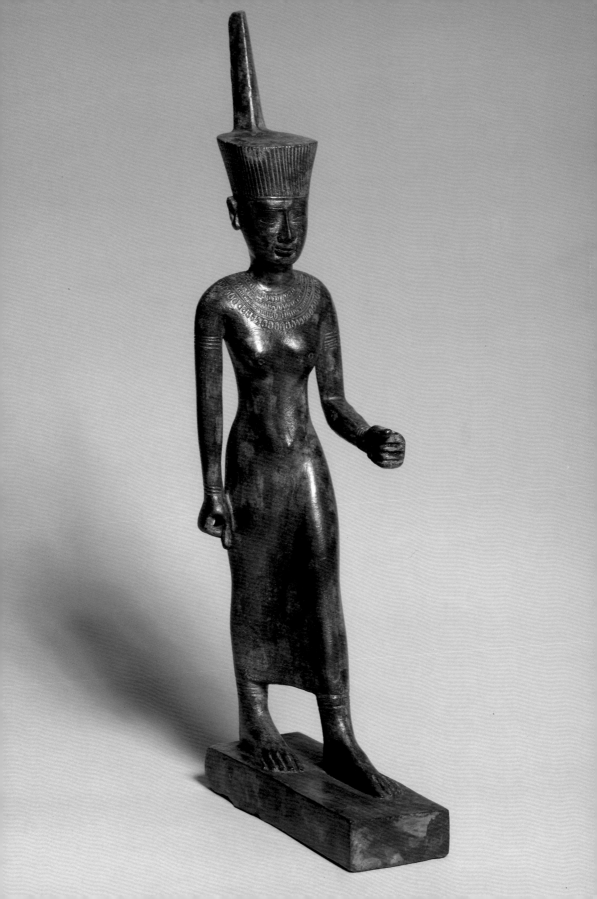

VOTIVE STATUETTE
WITH THE IMAGE
OF PTAH

E.331.1954 Steatite. Height 6.8 cm.
Late Period, early Dynasty XXVI, 715–610 BC.
Bequeathed by Sir Robert Greg.

This delightful figure represents a devotee of the creator god Ptah (see no. 47), the grand artisan deity who fashioned the world. The worshipper is shown proffering a shrine with the image of the god Ptah in high relief. The man rests his hands and chin on the top of the shrine. He wears a bag wig, an introduction of the Late Period, and he is shown with very large hooded eyes, fleshy cheeks and finely modelled nose and mouth.

The pose, the naturalism and the small scale of this sculpture are highly unusual. The man kneels on his right knee and the sole of this foot is exposed. This asymetric position with left knee raised can probably be explained by the preferred rightward orientation in Egyptian art. Thus, when figures are represented striding (no. 44), it is always the left leg which is shown advanced, and here it would be the left leg which would lift the figure, were he to stand. The presence of the bag wig and the deep eye–sockets date this figure to early Dynasty XXVI.

It is not clear why the man is modelled on such a small scale. Perhaps his limited resources prevented a larger commission. One wonders whether he had also dedicated a full-scale shrine and whether this sculpture records that dedication. It is regrettable that this fine piece was not inscribed at least with the man's name and titles.

Further reading Bothmer, ESLP, cat. nos. 20, 21.

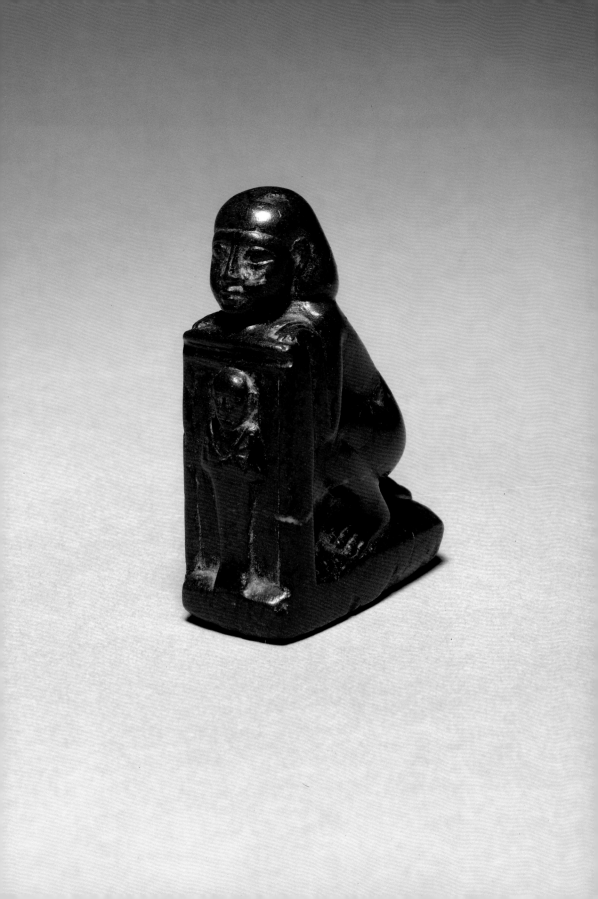

CARIAN GRAVE STELE

—

E.1.1971 Limestone, with surface pitting once plastered.
Dimensions: 91.2 cm × 37 cm × 8 cm. Late Period, late Dynasty XXVI,
550–500 BC. From Saqqara, Sacred Animal Necropolis, votive pit.
Given by the Egypt Exploration Society.

Carians settlers came to Egypt from south-west Asia Minor, between the Meander and the Indos, and bordered by Lydia on the north, Phrygia on the east and Lycia on the south. Their presence as mercenaries in Egypt is attested from the seventh to the third century BC. Herodotus recorded that King Psamtik I was aided by 'the men of bronze who came from the sea', meaning the Ionian and Carian mercenaries. The king settled the Carians in the Delta, north-east of Bubastis, and later King Amasis (ruled 570–526 BC) resettled them in Memphis so they were known as 'Caro-Memphites'. Numerous Carian stelae have been found at Saqqara.

This stele with rounded top and winged sundisk is Egyptian, but the weakly incised figures, instead of boldly carved sunk or raised relief (nos. 45, 49), are unusual for such a large monument. A woman and man face each other and both raise a hand to stroke the other's chin while their lowered hands are clasped. Their profile position, gestures and style of clothing are decidedly un-Egyptian. The lady wears a long thin pleated belted undergarment of Greek type whose excess length is pulled over the belt as an overfall. Over this she wears a heavier garment as a shawl. The man wears a long thin garment and a heavier short Greek cloak.

The tender gestures suggest a final farewell, though it is not absolutely clear who is the survivor. If we refer to Egyptian iconographic rules, the deceased is usually on the left or divine side of the stele, the female in this case is the deceased. A faint and partially preserved Carian inscription, occurs along the sides stating the names and referring to each as a beloved consort.

This Carian stele was presumably executed by a Carian or East Greek artisan resident in Egypt. The stele, datable to around 550–500 BC, was reused in a fourth-century BC pit at Saqqara. The farewell scene, also known from Greek decorated pottery, was a precursor of the emotive scenes on Attic stelae of the fifth and fourth centuries BC.

Further reading O. Masson *et al.*, *Carian Inscriptions from North-Saqqâra and Buhen, Memoirs of the Egypt Exploration Society*, 5 (1978), pp. 22, 61ff. For ancient references to the Carians see Herodotus, II, 154 and Diodorus, I, 67.

RELIEF OF KING ACHORIS

—

E.G.A.75.1949 Sandstone (repaired) with traces of blue pigment on wig,
red on face and white on background. Height 18.25 cm, width 14.5 cm.
Late Period, Dynasty XXIX, reign of Achoris, 392/1–379/8 BC.
Bequeathed by R. G. Gayer-Anderson.

King Achoris was probably not a native Egyptian, but came from a nomadic tribe living in Palestine. He could not have inherited the throne, but the nature of his rise to power is unknown. He ruled as king during Dynasty XXIX, a period of great unrest, following the First Persian Occupation of Egypt (525–404 BC).

Reliefs of Achoris are extremely rare and sculptures in the round of him are unknown, except for two shawabtis from the Delta city of Mendes where his tomb, no doubt plundered, may have been located. In this raised relief from an unknown monument, Achoris wears a short trapezoidal wig with tightly escheloned curls. His only head-dress is the diadem, probably made of sheet gold, with royal uraeus wound round. The lower half of the cartouches above the diadem identify this elusive king. Achoris' face reveals an elegant youthful ideal which differs from the squareness of the Kushite heads (nos. 48, 49). The root of the nose is low, placed level with the corner of the eye so that the eye itself is given prominence. The lower part of the face is defined by a small round chin, fleshy throat and short neck (compare the earlier Middle Kingdom style, no. 8). These are stylistic features characteristic of the Late Period.

After initially behaving cautiously towards the Persians, Achoris, according to a Greek account, allied himself with the king of Cyprus in revolt against the Persians who were also threatening Greek cities in Asia Minor. During Achoris' reign the Persians were largely engaged elsewhere and Egypt could enjoy relative prosperity. The king is known to have made endowments to some temples. However the Persian menace remained, and after three assaults Egypt succumbed to occupation for the second time (341 BC). Alexander the Great liberated Egypt permanently from the Persian yoke.

Further reading C. Traunecker et al., *La Chapelle d'Achoris à Karnak* II, Recherche sur les Grandes Civilisations, 5 (Paris, 1981); B. G. Trigger, B. J. Kemp, D. O'Connor and A.B. Lloyd, *Ancient Egypt: A Social History* (Cambridge, 1983/repr. 1989), chapter 4.

DOORJAMB OF THA-ISET-IMU

—

E.5.1909 Limestone, plastered and painted.
Dimensions: 1.26 m × 34 cm × 14 cm. From Memphis,
Palace of Apries, reused from the owner's tomb. Late Period,
Dynasty XXX, reign of Nectanebo I, 378–360 BC.
Given by the British School of Archaeology.

Some private tombs of the Late Period have survived, but no trace so far has been found of any royal tombs dating to the final phase of Dynastic history. There is no sign of the Alexandrian necropolis with the opulent tomb of Alexander the Great which was visited and described in antiquity, nor of the tombs of the subsequent Ptolemaic rulers.

It seems that artisans of the Late Period derived many of their ideas about style and motifs for wall decoration by visiting tombs and monuments of earlier periods. This antiquarianism is evident from the crisply carved doorway jamb from the tomb of Tha-iset-imu. He stands, heavily cloaked on one face of the jamb, below an account of his professional achievements. He was the Royal Herald, the King's Secretary and Confidant and a director of royal building works, and lived during the last native Egyptian Dynasty, a few years before the conquests first by the Persians and then by Alexander the Great. Tha-iset-imu served King Nectanebo I (379/8–361/0 BC). The text on this doorjamb also venerates a man who served in a similar position to Tha-iset-imu, but during the reign of the earlier king Amasis of Dynasty XXVI (570–526 BC).

The deceased is carved according to a fourth-century BC ideal with a smooth 'egg head' and benign smile, also characteristic of sculptures in the round. He holds his garment together with his left hand which is cleverly positioned so that we see his royal cartouche-shaped signet ring, the only example of this form known from relief representation. On the other face of the jamb, the side which would have been inside the tomb proper, the decoration is in raised relief. Tha-iset-imu is shown being suckled by a deified Lady Semset. Such scenes were traditionally reserved for kings who were mythically suckled by goddesses. The identification of the Lady Semset is uncertain.

The companion doorjamb, is in The Brooklyn Museum, though it was not found at the same time as the Fitzwilliam example.

Further reading W. M. Flinders Petrie, *The Palace of Apries, Memphis,* II (London, 1909), pp. 13, 20–21, pls. 17, 25; Bothmer, *ESLP,* cat. no. 74 and R. Fazzini *et al., Ancient Egyptian Art in The Brooklyn Museum* (London and Brooklyn, 1989), cat. no. 78.

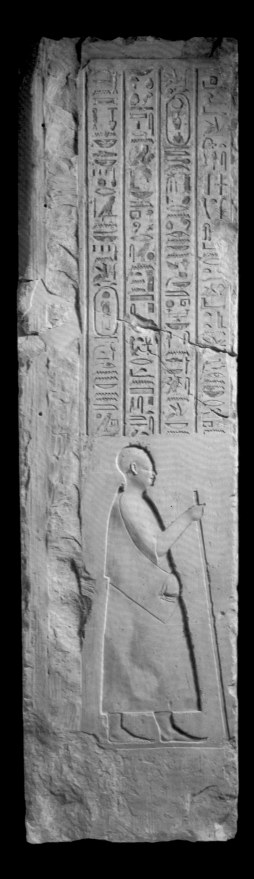

QUEEN ARSINOE II

—

E.27.1981 Basalt. Height 42 cm.
Ptolemaic Period, middle of the second century BC.

Apart from images of the Divine Consort (no. 49), representations of queens and private women virtually disappeared in Dynasty XXV (seventh century BC) and did not reappear until after the conquest of Egypt by Alexander the Great (332 BC). It is difficult to account for the lack of female representation spanning two and a half centuries, unless there existed some sort of temple prohibition. During the Greek-speaking Ptolemaic Dynasty (305–30 BC) women, especially in the city of Alexandria, enjoyed freedom and rights unknown elsewhere in the Hellenistic world. Egypt was opened for massive Greek immigration, and under Ptolemaic patronage gifted historians, theorists, philosophers, theologians, writers, architects, artists and, no doubt, early feminists flocked to Alexandria.

Despite an environment of vigorous intellectualism, royal brother-sister marriage was introduced together with the deification of the Greek kings and their queens. Arsinoe II, sister-wife of Ptolemy II was said to be carried off to heaven by the Greek twin Dioscuri, and her cult was instituted by the appointment of a priesthood and state festivals. Her attributes included the double cornucopia.

It has been argued that the approach to female sculpture in this period was essentially Hellenistic Greek and not Egyptian. However, features such as the compressed shoulders, prominent breasts, rounded abdomen and thickened thighs are present both in native sculptures and temple reliefs in the traditional pharaonic idiom and Hellenistic marble statuary. What was new in the sculptural production of the Ptolemaic Period was the method of drapery. Women were not only shown with the long close-fitting dress with shoulder straps, but also with the crinkly Greek undergarment (chiton) and large over-mantle (himation), knotted in the so-called Isis knot over the right breast. In this fragmentary draped torso of Arsinoe II the mantle folds cascade from the knot and the textures are defiantly modelled so that the thin undergarment appears thicker than the heavier mantle which clings, as if wet, to the rounded female contours.

The choice of Egyptian stone, the back pillar (no. 44) and consequent impossibility of figural torsion, place this sculpture within the native Egyptian sculptural framework. Although uninscribed, this may have been a cult statue for the queen's own chapel, and not a votive one dedicated to another deity.

Further reading R. S. Bianchi *et al.*, *Cleopatra's Egypt: Age of the Ptolemies* (Catalogue of an exhibition at The Brooklyn Museum) (Mainz, 1989), fig. 19; cat. nos. 64–66, 72.

NAKED WOMAN

—

E.83.1937
Egyptian Blue. Height 10.5 cm.
Early Ptolemaic Period (?), 300–275 BC.
Bequeathed by C. S. Ricketts and C. H. Shannon.

The female nude was infrequently represented in the Late Period of Egypt. Indeed, throughout Egyptian history, the image of the nude was almost invariably confined to the obscurity of the tomb. Often, the female garments are so revealing in sculpture and relief that it is only the presence of a hem at the ankle that distinguishes an image of a concubine from a modest woman.

The woman shown here wears a short hairstyle, turned up slightly at the back, her eyes are slanted and rimmed, her cheeks are fleshy and she smiles benignly. Her neck is thick and short, her shoulders compressed so that her bosom is quite prominent, and this is emphasized by her high and narrow waist. The shapeliness of the figure is somewhat subdued by the long straight arms and rigid legs. She is firmly fixed to a square plinth and a back pillar which is perforated for suspension. It is unknown whether she was deposited as a votive in a temple or in a tomb as a companion for the dead, sometime in the early fourth century BC.

The material of the statuette is known as 'Egyptian blue', this was a kind of fused siliceous frit coloured blue with copper compounds, as distinct from faience (no. 16). The material could be moulded or hand-worked or, as in the case of the present figure, was probably made by a combination of both procedures. 'Egyptian blue' was used to produce statuettes and other small objects in the round, and was also ground to form a pigment.

Further reading Bothmer, ESLP, p. XXXVII, cat. no. 95; for 'Egyptian blue' see Lucas, *Egyptian Materials*, pp. 340–43.

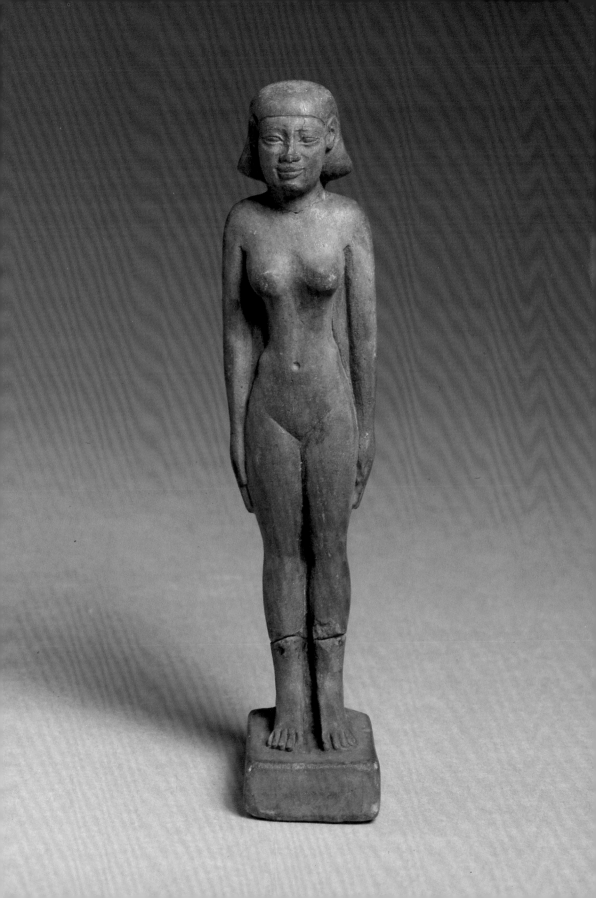

ISIS AND HARPOKRATES

—

E.G.A.121.1949
Wood with plaster and pigment.
Dimensions: 27.3 cm × 12 cm × 0.2 cm.
Early Ptolemaic Period (?), 300–275 BC.
Bequeathed by R. G. Gayer-Anderson.

The goddess Isis, wife of Osiris, appears on this fretted furniture relief before her infant son Horus who is seated on a lotus blossom. Isis wears an emblem of the royal throne as a crown; appropriately the hieroglyph also spells her name. Horus was believed to have gathered the dismembered body of his father Osiris and to have vanquished his murderous uncle Seth. The Egyptians regarded the living pharaoh as Horus incarnate and once dead, he reigned supreme over the dead as Osiris. Horus assumed special qualities which resulted in variations of his name. Harpokrates was Horus as a child in the emphasized role as the son of Isis, shown with a side-lock, a sign of youth, and often with his hand to his mouth as a child. He was also hailed as the solar son who sat on the lotus blossom, often with the Double Crown emphasizing his role as the heir of Osiris.

This wood fragment probably once formed part of a piece of royal or temple furniture in the Ptolemaic Period. The upper part of the goddess is modelled in high relief in order to accommodate her arms which gesture before her son. A blank rectangle in front of her was meant to be the text matrix for the words she spoke. The scene is meant to be read from left to right in accordance with the preferred rightward orientation of Egyptian hieroglyphs and scenes.

The surface of the wood, once plastered and painted, has decayed revealing an inked proportional grid (no. 59). The grid enabled the artisan proportionally to reduce secondary figures, images and texts within each scene.

Further reading R. Fazzini *et al.*, *Ancient Egyptian Art in The Brooklyn Museum* (London and Brooklyn, 1989), cat. no. 79; for the most recent discussion on the grid see Robins, *Proportion and Style*.

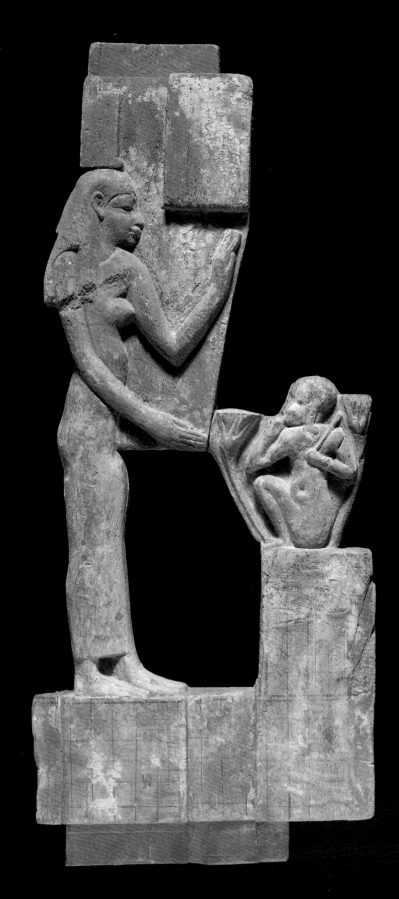

THE VANQUISHED ENEMY

—

E.214.1939 Limestone. Height 13 cm, width 13 cm. Early (?)
Ptolemaic Period, fourth – third century B C. Given by G. D. Hornblower.

Strong kingship has almost always gone hand in hand with military expansionism from antiquity to the present. Yet Egypt with its enduring three thousand year old culture was for the most part an isolationist country. Various rulers had ventured with their armies into the Levant and into southern Nubia, not necessarily to absorb and colonise those areas, but to secure trade or tribute, and also for strategic reasons. Unlike the Phoenicians, the Egyptians were not seafarers and chose not to create large-scale trade connections elsewhere in the Aegean. Indeed, apart from a few commodities, the Nile Valley and Delta provided its people with all its needs, metaphorically guaranteed by the ruling king. As we have seen from the earliest times (no. 5) representations of the king repelling abhorrent foreigners magically secured Egypt's borders.

Egypt was a well-regulated cosmos and its temples symbolized the primeval mound emerging from the watery abyss. Individual architectural elements of the temple reflected the elements of the cosmos: the floor of the temple was the earth, the pylon or gateway represented the horizon between two mountains where the sun set, the columns and their capitals imitated plants growing on the primeval mound and the ceiling symbolized heaven. Representations of the annihilation of foreign enemies, particularly on the exterior temple walls, were the symbolic language used for the mystical maintainance of cosmic order by the king.

A favourite scene on the temple pylon exteriors showed the king grasping a group of foreigners by a collective top knot and raising his mace to strike them. In this fragment of a trial piece, the sculptor has reinforced the powerful scene with the addition of a lion, a metaphor for the king. The foreigners are shown both subdued on one knee and also vainly trying to flee with one knee raised. One is bearded, representing a northerner wearing protective amulet, clearly ineffective in this instance, and the other is presumably a southerner. Both enemies raise an arm as if to ward off the blow. The scene is modelled in raised relief, but this appears within deeply sunk contours. The background field with its scored proportional grid had yet to be removed when work on the piece was discontinued. It is possible that this unfinished relief with only two foreign enemies was a simplified trial piece from an artist's studio.

Further reading Robins, *Proportion and Style.*

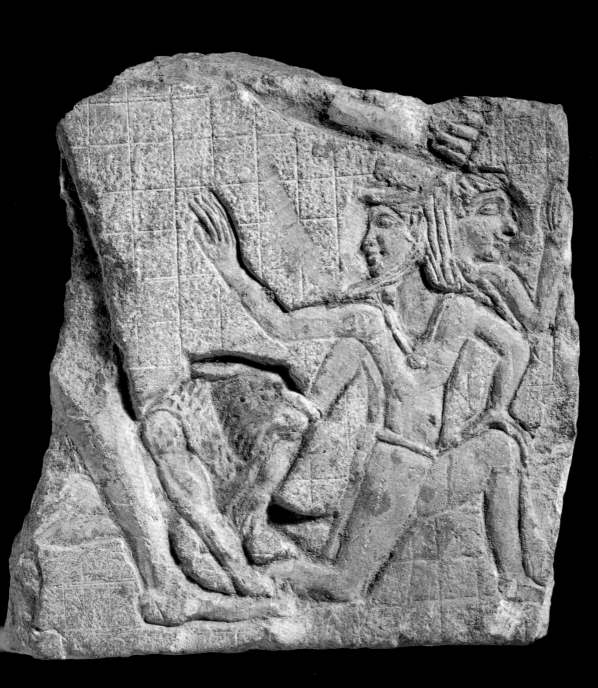

SCULPTOR'S MODEL OF A GODDESS

—

*E.G.A.4338.1943 Limestone, with areas of restoration at the back of the
head and wig lappet and chest. Height 10.7 cm, width 9.25 cm. Ptolemaic Period,
probably reign of Ptolemy III, 246–222 BC. Given by R. G. Gayer-Anderson.*

In a pictorial system in which all the salient aspects of the individual are meant
to be shown, we do not expect to see an abbreviated figure such as this on a
small relief plaque. And yet great numbers of these pictorial 'windows' showing
royal and divine busts or sacred animals survive mainly from the Ptolemaic
Period. These plaques are traditionally called sculptors' models since most
are unfinished, sometimes showing the remains of a proportional grid and
little or no trace of pigment. A very small number, however, have inscribed
dedications, and on this basis some scholars call them ex-voto plaques. The
two functions may not be mutually exclusive, the primary function was as a
teaching aid or practise relief which may have been dedicated subsequently.
Most of the figural reliefs appear stylistically datable to the early Ptolemaic
Period, when perhaps the immigration of numbers of foreigners resulted in
some non-Egyptians being inducted into the royal sculptural workshops.

The Egyptian goddess wears the vulture head-dress but no crown. Whereas
queens could be shown with the vulture head-dress in the New Kingdom, in the
Ptolemaic Period only a goddess or a dead and deified queen wore this head-gear,
but also with a crown. The present example shows a generic image of a goddess,
surely an indication that the relief is a sculptor's model and not a completed
work. The verso of the plaque was also decorated with a relief of a bust of
Harpokrates on a larger scale and not within a 'window'. A double-sided relief with
two different subjects on different scales was unlikely to be used as a votive object.

Distinctive facial features for the reign of Ptolemy III are the low root of the
nose, the fleshy cheek and 'golf-ball chin' and short thick neck. During this
reign, female proportions were also markedly distinguished from those of the
male by a compression and rounding of the shoulders and thickening of the arms
to the extent that the straps of the garment are displaced here by the broad collar
and are positioned off the shoulder (compare no. 49). These excesses disappeared
in the reliefs of subsequent reigns. This small relief shows the importance of art
historical observation when context is lost and an inscription is absent.

Further reading B. V. Bothmer, 'Ptolemaic Reliefs I; II; III; IV', BMFA, 50 (1952), 19–27;
49–56; BMFA, 51 (1953), 2–7; 80–84; E. Vassilika, *Ptolemaic Philae, Orientalia Lovaniensia
Analecta*, 34 (1989), pp. 131–133.

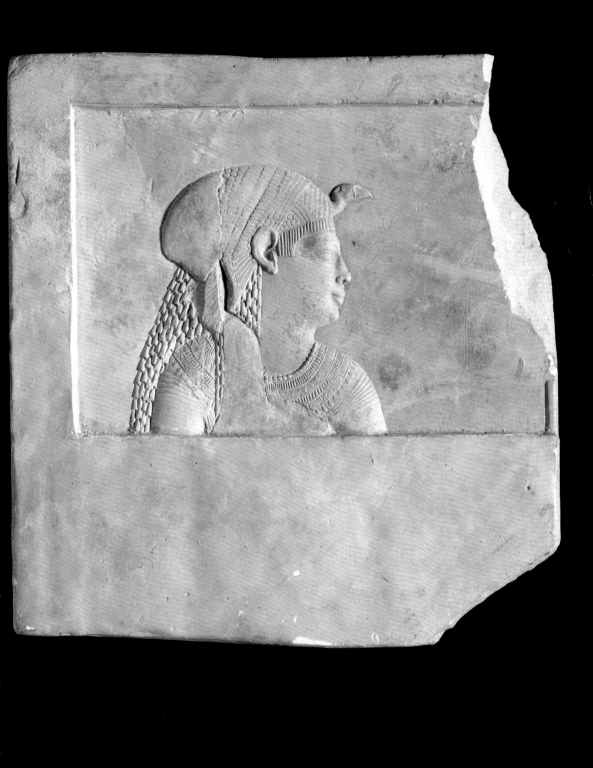

THE GODDESS TAWERET

E.22.1955 Wood. Height 27.5 cm.
Late Ptolemaic Period, second – first century B C.
Given by Sir W. P. Elderton.

Taweret was an awesome looking but friendly goddess manifest as a pregnant hippopotamus standing upright on leonine legs. She has post-natal breasts, human arms, leonine paws and the spine and tail of a crocodile. Her muzzle was always represented open, revealing her teeth, and her long hair was carefully combed and parted into three lappets. Taweret was a goddess of marriage and child-rearing, and as such she shared traits including her crown, not preserved here, with the goddess Hathor. Taweret did not have a specific cult site and few chapels were dedicated to her, but she was worshipped where Hathor was venerated. She was believed to protect women from evil and for this reason was often represented like her fantastic male counterpart Bes on bedroom furniture and furnishings (no. 24). By logical extension, Taweret was also thought to protect the sun at its rising.

The maternal Taweret also played a further function in the rebirth of the dead. Perhaps this role was derived from an association with sleep, which may also account for her image on beds and head-rests. According to another tradition, she held the evil crocodile Seth so that Horus could slay it. This might account for the fact that her amulet was frequently worn by children to prevent encounters with snakes and crocodiles.

This wooden sculpture was carved together with its plinth from a single piece of wood. The connective material between and behind the legs was removed for a more realistic effect. The sculpture could have come from a tomb sometime during the Ptolemaic Period in the second or first century BC.

Further reading LÄ, VI, 494–497.

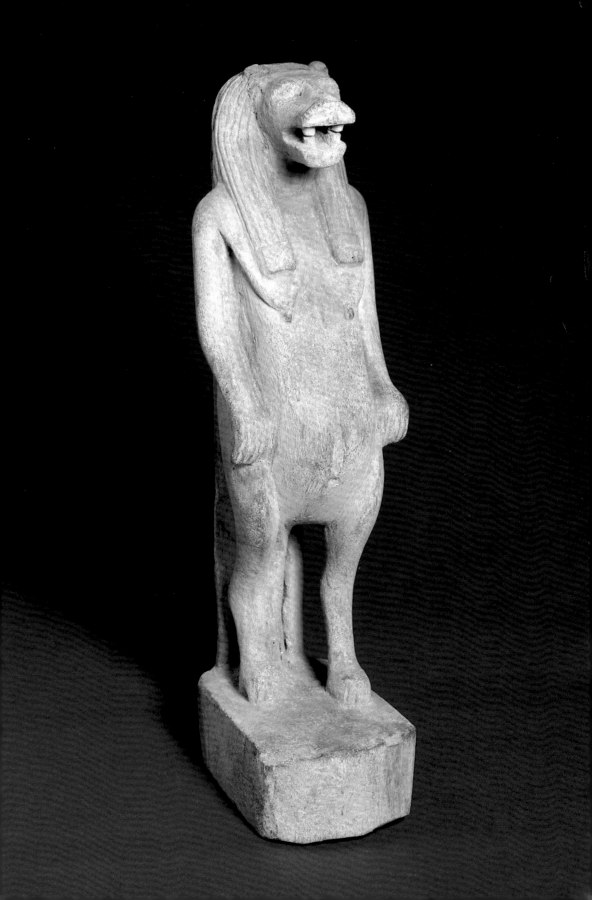

A MATURE MALE HEAD

—

E.83.1954 Green schist. Height 10.5 cm. Roman Period,
first century AD. Given by Howard Carter to Sir Robert Greg and bequeathed.

We are used to seeing Egyptian sculpture modelled in ideal terms and according to an eternal vision of youth. Age might be surmised from the inscriptions on a sculpture but signs of age on the face were rarely shown, and never on sculptures of deities. However, a stark realism composed of a repertory of formulae was introduced in private male sculptures from the seventh century BC onwards. The fact that ideal male images continued to be sculpted and that maturity was not applied to female sculptures also suggests that a climate for real portraiture did not truly exist in Egypt.

Classical scholars, having ignored the long tradition of native Egyptian non-ideal images, usually wrongly regard portrait-like heads as owing to the Hellenistic Greek presence in Egypt. The present head shows a mature man whose eyes, once inlaid in different materials, were gouged out. The crown of his head, possibly flawed, was carved separately and applied, and the absence of hair at the sides suggests a shaven pate. The eyes are closely set under a strong brow with a fleshy upper lid that overlaps the lower rim of the eye, and this is further graphically emphasized by deeply carved crow's feet at the outer corners. Several diagonally sculpted ridges punctuate the loose fleshy cheeks, and the thin lipped mouth is framed by strong irregular naso-labial furrows.

Despite the convincing signs of age, there are other examples of schist stone heads of mature men, known as 'Green Heads', which are datable to the last two centuries BC. In all cases the superb volumetric treatment is likewise underscored by linear details such as crow's feet and the scored left brow. However the veristic treatment on the present example is most extreme, and there is no evidence of a back pillar which suggests a later date during the Roman Period. The fact that the head fits into a stylistic development is perhaps disappointing to the modern observer hoping for a true portrait. On the other hand, sculptural devices and portraiture may not always be mutually exclusive as they are still in use by portrait sculptors and photo-fit experts today.

Further reading B.V. Bothmer, et al. ESLP, cat no. 127, R.S. Bianchi *et al. Cleopatra's Egypt: Age of the Ptolemies* (Catalogue of an exhibition at The Brooklyn Museum) (Mainz, 1989), cat nos. 31, 35, 44–47. For a published attribution of this head to the emperor Vespasian, see Z. Kiss, *Etudes sur le Portrait Impérial Romain en Egypte, Travaux du Centre d'Archéologie Mediterranéenne de l'Académie Polonaise des Sciences*, 23 (1984), pp. 51–52.

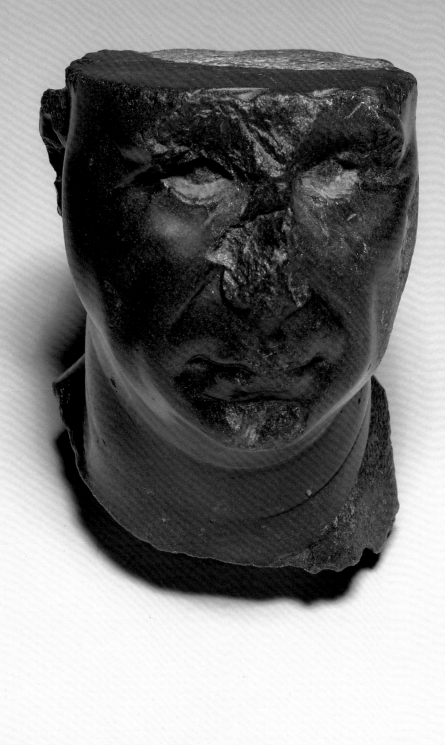

A MUMMY

—

E.63.1903 Linen wrapped human remains with painted wood panel
over face. Height 1.62m, width 34 cm.From El-Hibeh. Roman Period,
second century A D. Given by the Egypt Exploration Fund.

With the immigration of Greek-speaking people to Egypt during the three centuries before Christ, there was some intermarriage and cross-cultural mingling. In general though, immigrant Greeks as the ruling elite preferred to accentuate social barriers. By the time of the Roman Conquest (30 BC) Egypt was bi-cultural.

Despite the separateness of the two cultures, many Greeks preferred mummification and interment rather than cremation. Mummy portraits, some of which are inscribed with Greek names, show naturalistically painted images and were fixed in the mummy wrappings. Egyptian religious imagery was painted on the outer mummy wrappings. Such panel portraits, many of them separated from the mummies at the turn of the century, were usually painted by the encaustic method with pigment suspended in melted wax and applied with a brush, or in a less fluid condition by means of a spatula-like tool. The panels show the individuals wearing period jewellery, clothing and coiffures. Often the panels were trimmed by the embalmers to fit within the bandages, prompting scholars to debate whether they were painted while the deceased still lived and subsequently used at the burial. In any case, the disparity in style, medium and quality point to a different artisan for the panel from the one responsible for the bandage decoration.

The present mummy is that of a young man who died aged between thirty and thirty-five according to an x-ray analysis of the skeleton, of causes unknown. He has curly hair, with a gilded laurel wreath, a funerary tradition dating back centuries among the Greeks. His bushy eye-brows join over his nose, not an Egyptian pictorial convention, and he is shown with full beard, uncommon for the Egyptian natives. The body is enveloped in a stiffened red-dyed cloth with gilded decoration. On both shoulders the deceased is protected by a crudely painted *wedjat*-eye and over the chest by the winged sundisk, falcons and a protective funerary deity. Below, the deceased is shown on an embalming table ministered to by the embalming god Anubis (actually a priest by proxy). A falcon and winged sundisk protect the feet painted on the bandages.

Further reading K. Parlasca, *Mumienporträts und verwandte Denkmäler* (Wiesbaden, 1966), 40 n. 161, pl. 24, 1; W.M. Flinders Petrie, *Roman Portraits and Memphis*, IV (London, 1911); C.C. Edgar, *Catalogue Général des Antiquités du Musée du Caire: Graeco-Egyptian Coffins, Masks and Portraits* (Cairo, 1905).

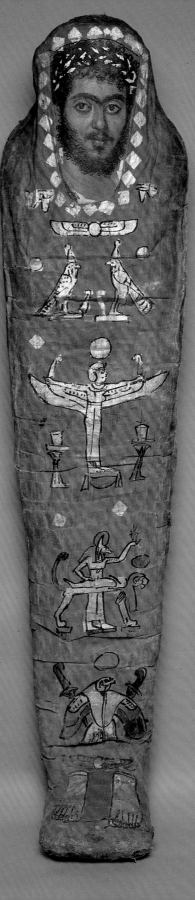

COPTIC CASKET

—

E.1.1962 Wood with ivory relief, iron and bronze lockplate.
Length 8.5 cm, height 6 cm. Roman Period, fourth century AD.
From Qasr Ibrim. Given by the Egypt Exploration Society.

By the fourth century AD, Egypt was profoundly and almost completely a Christianised society. Indeed the country had established a tradition of Patristic literature, which contributed to a lively theological debate focusing on the nature of Christ. An Egyptian school of thought stated the unity of Christ's nature, but this was condemned by the Fourth Ecumenical Council (Chalcedon, AD 457) which declared his two natures (divine and human) to be distinct yet inseparable. Recalcitrant Egypt was cut off from the rest of the Christian East, and its monophysite faith is known as the Coptic Church.

It is difficult to reconcile the profound Christianity of Coptic Egypt with the art of the period. Pagan art continued and pagan images could coexist with Christian ones. Thus, friezes with the Greek god Dionysos could embellish a textile also decorated with Christian images. The present casket comes from a cemetery in Nubia, where the imagery on the grave goods is pagan, though some motifs are ambiguous. For example, the stylized birds on one long side of this casket could be Christian in another context. The opposite face of this casket is decorated with lotus blossoms and the short sides with rosettes, a tie on one side and a bird, mostly obscured by the metal lock, on the other. The lid shows the naked god Dionysos standing in a contrapposto pose with right arm lowered to a panther, highlighting his eastern origins.

Numerous bone and ivory inlays from caskets large and small have been found in Egypt and Nubia, showing Dionysian images. The tomb from which this casket comes was a two-chambered one with mudbrick vaults, covered with a rubble tumulus, and it belongs to the Nubian x-group, renamed Ballana culture, datable to the fourth and fifth centuries AD. Popular pagan religion derived from Egypt continued to the middle of the sixth century, when the Christian faith finally penetrated into Nubia. The remains from sites of the Ballana culture also testify to another cult, that of the vine. From the remains, wine was evidently consumed prodigiously. Perhaps the profusion of images of Dionysos, god of the vine, ought to be considered in the light of this custom.

Further reading A. J. Mills, *The Cemeteries of Qasr Ibrim* (London 1982), intro., pp. 9ff., pl. VII; W. Y. Adams, *Nubia: Corridor to Africa* (London, 1977), pp. 390–424; The Brooklyn Museum, *Africa in Antiquity: The Arts of Ancient Nubia and the Sudan*, 2 vols. (Brooklyn, 1978); Lila Marangou, *Bone Carvings from Egypt In: Graeco-Roman Period* (Tübingen, 1976).

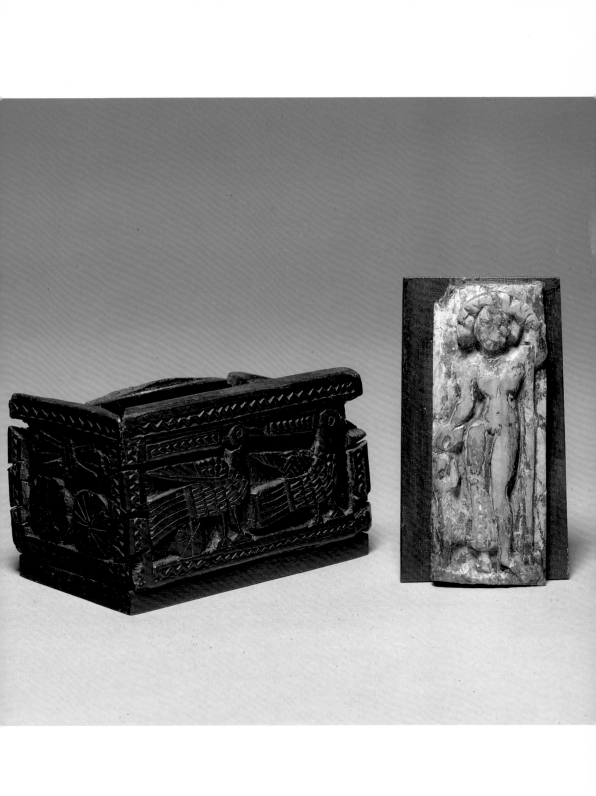

SELECTED BIBLIOGRAPHY
AND ABBREVIATIONS

Aldred, *Akhenaten/Nefertiti*: Aldred, C. *Akhenaten and Nefertiti*. Brooklyn, 1973.

Aldred, C.: *Egyptian Art*. London, 1980.

Baines, J. and J. Málek. *Atlas of Ancient Egypt*. Oxford, 1980.

Bénédite, *Objets de Toilette*: Bénédite, G. *Catalogue Général des Antiquités Égyptiennes du Musée du Caire, nos. 44301–44638*. Cairo, 1911.

BIFAO: *Bulletin de l'Institut Français d'Archéologie Orientale, Le Caire*

BMFA: *Bulletin of the Museum of Fine Arts, Boston.*

Boston, *Egypt's Golden Age*: Boston, Museum of Fine Arts, *Egypt's Golden Age: The Art of Living in the New Kingdom 1558–1085 BC*. Boston, 1982.

Bothmer, ESLP: Bothmer, B.V. et al., *Egyptian Sculpture of the Late Period, 700 BC to AD 100*. Brooklyn, 1960. Reprint New York, 1969.

Bourriau, *Pottery*: Bourriau, J. *Umm el-Ga'ab. Pottery from the Nile Valley before the Arab Conquest*. Cambridge, 1981.

Bourriau, *Pharaohs*: Bourriau, J. *Pharaohs and Mortals: Egyptian Art in the Middle Kingdom*. Cambridge, 1988.

Brunner-Traut, *Sketches*: Brunner-Traut, E. *Egyptian Artists' Sketches. Figured Ostraka from the Gayer-Anderson Collection in the Fitzwilliam Museum*. Cambridge and Istanbul, 1979.

Corteggiani, J. -P. *The Egypt of the Pharaohs at the Cairo Museum*. London, 1987.

Fischer, H. G. *The Orientation of Hieroglyphs, Egyptian Studies*, II. New York, 1977.

Harpur, Y. *Decoration in Egyptian Tombs of the Old Kingdom: Studies in Orientation and Scene Content*. London and New York, 1987.

Hayes, *Scepter*, I/II: Hayes, W. C. *The Scepter of Egypt: A Background for the Study of Egyptian Antiquities in the Metropolitan Museum of Art*. 2 vols. New York, 1953 and 1959.

Hoffman, M. A. *Egypt before the Pharaohs*. New York, 1979.

James, T. G. H. *Ancient Egypt: The Land and Its Legacy*. Austin, 1988.

James, T. G. H., and W. V. Davies. *Egyptian Sculpture*. London, 1983.

JEA: *Journal of Egyptian Archaeology*. London.

LÄ: *Lexikon der Ägyptologie*. 6 vols. Wiesbaden.

Lucas, *Egyptian Materials*: Lucas, A. *Ancient Egyptian Materials and Industries*. 4th edn rev. London, 1962.

Luxor Museum of Ancient Egyptian Art. *Catalogue*. Cairo, 1979.

MDAIK: Mitteilungen des Deutschen Archäologischen Instituts Abteilung Kairo.

Myśliwiec, *Le Portrait*: Myśliwiec, K. *Le Portrait Royal dans le Bas-Relief du Nouvel Empire, Travaux du Centre d'Archéologie Mediterranéenne de l'Académie Polonaise des Sciences*, 18 (1976).

Peck and Ross, *Drawings*: Peck, W. H., and J. G. Ross, *Drawings from Ancient Egypt*. London, 1978.

PM: Porter, B., and R. L. B. Moss, *Topographical Bibliography of Ancient Egyptian Hieroglyphic Texts, Reliefs and Paintings*. 6 vols. Oxford.

Robins, *Proportion and Style*: Robins, G. *Proportion and Style in Ancient Egyptian Art*. London, 1994.

Russmann, E. R. *Egyptian Sculpture: Cairo and Luxor*. Austin, 1989.

Saleh, M., and H. Sourouzian. *The Egyptian Museum Cairo: Official Catalogue*. Munich and Mainz, 1987.

Schäfer, H. *Principles of Egyptian Art*. Trans. and ed. J. Baines. Oxford, 1974.

Schneider, *Shabtis*: Schneider, H. D. *Shabtis: An Introduction to the History of Ancient Egyptian Funerary Statuettes with a Catalogue of the Collection of Shabtis in the National Museum of Antiquities at Leiden*. Leiden, 1977.

Smith, W. S. *The Art and Architecture of Ancient Egypt*. Baltimore, 1958. 2nd edn rev. W. K. Simpson, New York, 1981.

Smith, HESPOK: Smith, W.S. *A History of Egyptian Sculpture and Painting in the Old Kingdom*. London and Boston, 1946.

Spencer, A. J. *Early Egypt*. London, 1993.

Terrace, E. L. B. and H. G. Fischer. *Treasures of the Cairo Museum*. London, 1970.

Vandier, *Manuel* III: Vandier, J. *Manuel d'Archéologie Égyptienne* III: *Les Grandes Époques. La statuaire*. Parts 1 and 2. Paris, 1958.

Vandier d'Abbadie, *Objets de Toilette*: Vandier d'Abbadie, J. *Les Objets de Toilette Égyptiens au Musée du Louvre*. Paris, 1972.

WB: *Wörterbuch der ägyptischen Sprache*. 5 vols. Berlin, 1955.